IMPROVE YOUR SLR PHOTOGRAPHY

David Kilpatrick

Collins

Published in 1983 by
William Collins Sons & Co Ltd
London · Glasgow · Sydney
Auckland · Johannesburg

Reprinted 1985

Designed and produced for
William Collins Sons & Co Ltd
by Eaglemoss Publications Limited

First published in *You and Your Camera*
© 1983 by Eaglemoss Publications Limited

ISBN 0 00 411770 0

Printed in Great Britain

CONTENTS

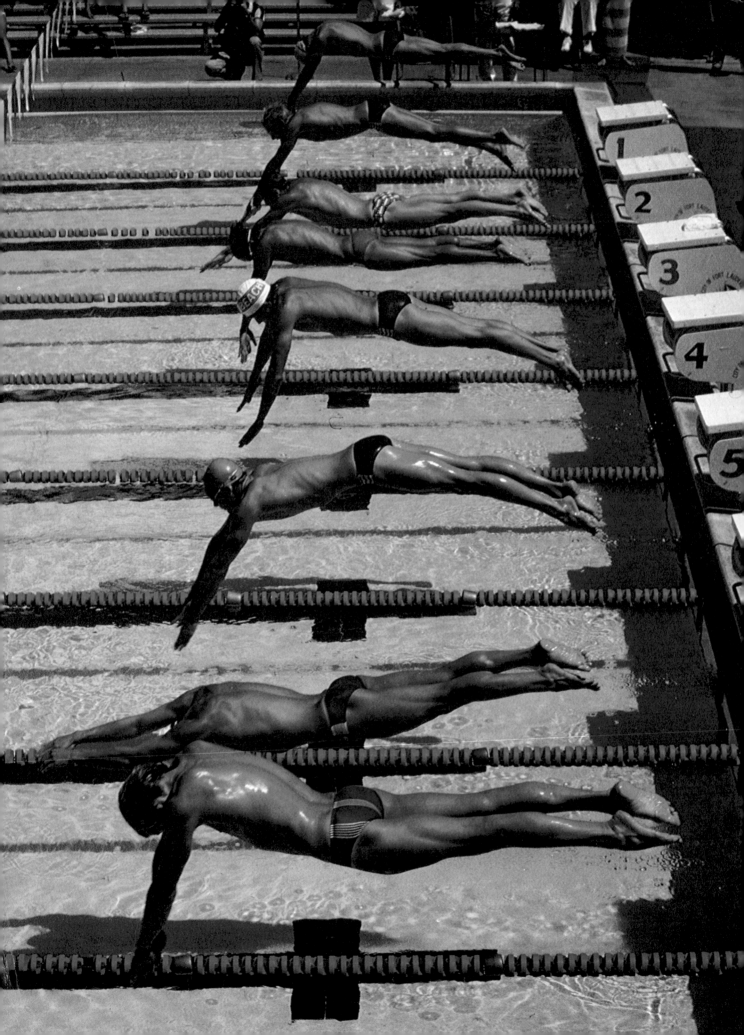

INTRODUCTION

Owning a 35mm single-lens reflex camera opens new doors to photographic opportunities. Start with a single SLR, and a whole range of new techniques, accessories, subjects and approaches lies before you. Understanding the use of those accessories, the potential of the techniques and the recognition of good subjects comes with experience of using your camera, expanding your system and testing ideas.

Improve Your SLR Photography starts off with ownership of a basic SLR and takes you step by step through all the vital experience needed to become a successful SLR user. The pictures have been taken specially, in everyday locations with familiar subjects and using the kind of equipment you probably own. Every point is explained as it really happened.

Throughout *Improve Your SLR Photography* you will find help and advice in concise, accurate form, fully illustrated with diagrams, pictures and close-ups of equipment. Everything in the course has been tested in practice to help you, as an SLR owner, become a better, all-round photographer.

Problem solving for better pictures:1

In photography there's nothing quite so disappointing as the picture which does not 'come out', or which fails completely to capture the interest or excitement of the subject which made you want to take the picture in the first place.

Can you honestly say that you have never made some of the mistakes illustrated here? Even the most experienced photographers occasionally take shots where the subject looks too small and gets lost, or where the exposure is completely wrong, or where the camera case appears in the picture. Even the very first stage, that of putting the film into the camera, has its dangers. Do you always remember to engage both sides of the perforations on the sprocket wheels and to watch the rewind knob to ensure it revolves as you wind on?

But avoiding these mistakes is only the first step to taking better pictures. You also need to learn what to look for in the viewfinder (composition) and to understand your camera so it will do what you want (technical know-how).

This 35mm SLR Improver Course tackles these problems and many more. It shows you how to avoid errors and basic faults and explains in clear picture steps how *you* can take better photographs.

CAMERA SHAKE
Problem: Picture blurred overall.
Cause: Moving the camera as you release the shutter, either through wrong technique or through not coping with difficult conditions such as shooting from a moving vehicle.
Solution: Follow the course and learn how to hold the camera correctly for steadiness, or use a tripod for support; which film to choose to ensure fast shutter speeds, and when to use flash.

POOR FOCUS
Problem: Part or, sometimes, all of the picture blurred and fuzzy.
Cause: Focusing incorrectly, or on the wrong part of the subject. The aperture chosen may not allow sharp focus throughout. The subject may be too close for focusing, or you may need viewfinder eyepiece correction.
Solution: Follow the Course to learn all about focusing.

SUBJECT MOVEMENT
Problem: Subject blurred, streaked or double imaged but background sharp.
Cause: Chosen shutter speed too slow to stop subject movement.
Solution: The Course explains how the shutter works and how speeds can be chosen to stop action; how to capture action by panning; how to use viewpoint to minimize movement blur; how to push film to get fast speeds in poor light; how to anticipate 'peaks' in the action, or use flash to stop it completely, or how to make subject blur work *for* you!

THINGS IN THE WAY
Problem: Dark, blurred blobs or parts of the picture obscured.
Cause: Things obstructing the lens— hair, case flaps, flash cables, fingertips; filters that are too small; lens hoods.
Solution: No current SLR shows you 100% of what the film sees, and with viewing at full aperture intrusions close to the lens can be too out of focus to be noticeable. The Course explains how to use camera controls and accessories to ensure that you get only what you want in the picture.

GHOSTING AND FLARE
Problem: Patches of spreading light, flares, or an overall weak, flat picture.
Cause: Light from the sun or other bright source entering the lens directly or at an angle and scattering.
Solution: Learn from the Course how to use a lens hood; how to use your own hand as a lens shade, or to change the composition or camera angle, and how to use filters to make flare work for you.

OVER–EXPOSURE

Problem: Picture too pale and washed out, no detail in the light tones.

Cause: Too much light allowed to reach the film. Aperture, shutter speed or film speed set wrongly; metering cell obstructed or misled by lighting conditions, or even faulty. Too fast a film loaded, or flash used too close to the subject. Lens failing to stop down correctly.

Solution: Learn how to use an exposure meter, and learn the rules of thumb for exposures in typical conditions. Learn about choosing films, and camera checking from the Course.

UNDER–EXPOSURE

Problem: Picture too dark, or print looks muddy with too little detail in shadows.

Cause: Insufficient light reaching the film. Aperture, shutter speed or film speed set wrongly; meter fooled by frontal direct light. Film suffers reciprocity law failure, or flash fails to fire.

Solution: As for over–exposure. Follow the Course and learn how to handle difficult lighting conditions and how to rescue mistakes.

CONTRASTY LIGHTING

Problem: Ugly shadows with no detail, highlight areas washed out.

Cause: The human eye adapts rapidly to accommodate wide changes in brightness, but film does not.

Solution: Follow the Course to find out how to match the contrast range of the subject to the film; learn about fill–in reflectors and using flash in sunlight.

FILLING THE FRAME

Problem: The subject looks tiny or insignificant, so the picture lacks impact.

Cause: You are too far away for the focal length of lens in use, you have tried to include too much, or you have framed the subject incorrectly.

Solution: The viewfinder is your picture frame and you have to look *at* the image, not *through* the camera. You have to look at the area of the picture taken up by the main subject compared to the total area.

In the first picture here (above), the girl occupies less than a tenth of the picture area, due to:

● Bad positioning of the subject. The photographer focused on the girl's face, which is correct, but then took the picture without re-framing to make better use of the height of the frame.

● Not getting close enough. Not all parts of a subject are equally important. Usually the face is the most expressive, interesting and individual feature. Therefore this should be given most emphasis.

For the second picture our photographer corrected these errors, got closer and filled the frame. And you can see the difference in impact and interest which has resulted.

The best possible way to see the shot you want to take with any camera is to look at the image formed by the lens—the picture which is focused on to the film. But to do this you would have to remove the film and the back of the camera, which is of course impractical. The solution to this is the single lens reflex camera's viewfinder. The image from the lens is reflected by a 45° angled mirror on to the viewing screen (usually at 90° to the film) in the camera top.

With a few SLRs you can view this directly by looking down on to it, but most have a pentaprism viewing system so that you can see the image through an eyepiece on the camera back.

The SLR is held at eye-level, the eyepiece magnifies the viewing screen, and the image seen is the right way up and the right way round. A black frame surrounds the picture area in the viewfinder, and the effect is similar to seeing a television screen or a projected slide in a darkened room.

The magnified image assists you to see details and, with a 50mm lens, the scale is almost the same as that seen by the unaided eye. Often other information, such as exposure data, is placed at the side of the screen.

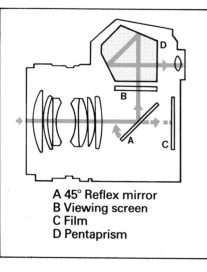

A 45° Reflex mirror
B Viewing screen
C Film
D Pentaprism

To allow accurate focusing the SLR focusing screen and the film are both the same distance from the lens. When the shutter release is pressed the 45° mirror (A) swings up and covers the screen (B). The shutter then uncovers, and therefore exposes, the film (C). Without a pentaprism (D) the image on the focusing screen would appear mirror-reversed from left to right (or upside down if the camera is used on its side for vertical compositions). You

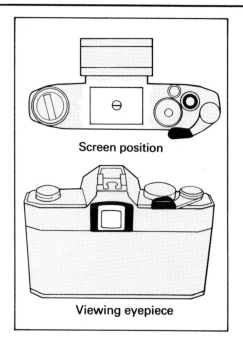

Screen position

Viewing eyepiece

would also have to look *down* into the camera to see the screen. The advantage of a pentaprism is that however you hold the camera, the image is the right way round. The eye piece allows you to view the focusing screen from the back of the camera.

USING THE FINDER SCREEN

SLR viewing screens are often bright and clear, and it is easy to forget to look at the composition and not just through the finder at the subject. Don't forget to look at what is happening at the edges and corners, as well as at the centre of the frame. Merely being aware of the entire frame area can improve many compositions. A common mistake is to place the subject dead-centre in the frame.

The example above shows the effect of allowing a central focusing area to act as an aiming device—a 'bulls-eye' composition. This is too easy to do, so try to ignore the central ring when finalizing the picture's composition after focusing.

When you concentrate solely on the centre of the viewfinder, parts of the subject at the frame edges can go unnoticed. It is difficult to cut off heads with an SLR camera, but it is easy to lose feet or hands unintentionally. This is common in portraits (with hands) and in groups (with feet). If there is danger of accidental cut-off, reposition your subject or move the camera to avoid it.

You must be equally careful that irrelevant details do not intrude into the frame edges. If something is in the background it may be acceptable, but a tiny part of an object or person showing near to or in front of the subject is distracting. Like the brightly coloured red sleeve in the picture above. The simple solution is to make a final check on the frame edges before you release the shutter.

HORIZONTAL OR VERTICAL?

All SLR cameras are designed to handle best horizontally, rather than vertically. When you lift a camera to your eye the natural tendency is to use it in the most comfortable way. For the majority of photographers that tends to mean holding the camera horizontally between your hands to take horizontal pictures. But this does not suit every subject. In the photograph above, for example, the photographer has used only a thin slice of the available frame for what is a naturally vertical subject. It is particularly important to frame the subject carefully when shooting slides, as it is not easy to improve the composition later by cropping unwanted detail.

Get used to holding your camera like this for vertical compositions. Right-handed people usually find this grip more comfortable. You should be able to switch from a horizontal to a vertical grip without changing hands.

See how a vertical subject benefits from a vertical composition. The closer viewpoint gives more detail and impact. Mixing upright and horizontal shots makes a set of pictures more interesting too.

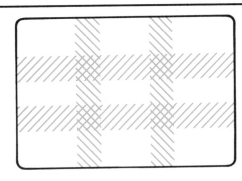

THE RULE OF THIRDS

Pictures somehow look much more interesting when the subject matter is well balanced in the frame. It is usually better to set the main subject to one side, or to place it at the top or bottom of the picture rather than dead-centre. The 'rule of thirds' is a convenient guide to rapid, appealing composition in the viewfinder.

Put simply, the rule states that the zones about one-third in from the picture edges have the most visual attraction because that is where you naturally tend to look first. The visual impact of important subject details is highest at the points where the zones intersect (see diagram above).

If the horizon cuts the composition exactly in half, the photograph looks uneasy. Try to use the upper or lower one-third lines when deciding where to position the horizon.

If you are photographing a group of children the tallest one is best placed on one of the vertical thirds rather than in the centre.

In the picture above the main elements, though simple, can be seen to coincide with the intersecting zones, making full use of the composition 'grid'.

Focusing for sharper pictures:3

Lack of sharpness is a common picture fault. Often this is due to incorrect focusing. Pictures that look sharp when the negative or slide is examined often turn out to be unsharp when large prints are made or the slide is projected. Even worse, unimportant parts of the subject may be sharp while important parts are blurred because they are out of focus.

For accurate focusing you must control the movement of the focusing ring precisely, know how to use focusing aids, know what part of the subject to focus on, and how to recognize that something is in focus.

Look through the viewfinder of your SLR and turn the focusing ring. You will see the image turn into a blur as the distance that is focused on (which you can read from the scale on the lens) gets farther from the actual distance of the subject. With standard lenses, small distances (a few millimetres) on the focusing ring represent large changes (several metres) in focusing distance, and therefore in the point of sharp focus.

Remember that the larger the size of print you are going to make, the more exact your focusing must be. Similarly, if only small prints are intended, or slides to be seen in a viewer, then you have a good safety margin.

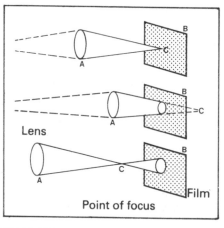

Point of focus

THE POINT OF FOCUS
A lens (A) focuses light rays into a cone shape. The rays converge to a sharp point (C), which is the point of sharp focus. If you put the film (B) at this point the image would be sharp. If the film is moved forwards or backwards tiny discs of light are recorded on the film rather than sharply focused points. In practice the film does not move but the lens does in focusing. The discs of light get bigger, and the image becomes progressively blurred, the farther you go from correct focus.

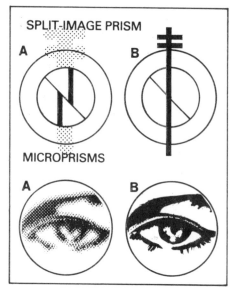

FOCUSING AIDS
Most focusing aids work by exaggerating incorrect focus. A split-image prism produces two separate parts of the image (A) which only fit together when focus is correct (B). The circle of microprisms shimmers (A) until focus is correct (B). You can also use the plain ground glass area of the screen for accurate focusing.

WHERE TO FOCUS
Often the clearest part of the subject for focusing is not the important part of the picture. Select the correct focusing area first, then try to find easy-to-focus detail within it. The most common focusing errors occur in portraiture where the nose, teeth, or hair (above) are wrongly chosen as focusing points. The subject's eyes hold the viewer's attention, and these or the eyelashes should always be the focusing target. After you have focused on the eyes, reposition the camera to give a pleasing composition.

In this portrait the eyes are perfectly sharp and the result is appealing. With more distant groups a striped shirt could be a good focusing target. Choose a sharp pattern, edge, line or strong texture, but whatever target you choose make sure it is stationary—a moving subject will quickly go out of focus. Sight the subject and turn the focusing ring until the image in the viewfinder looks sharp. Turn the ring gently back and forth to double-check that the image can't be made to appear any sharper.

IS YOUR EYESIGHT GOOD ENOUGH?

It is possible that despite taking great pains to focus accurately your pictures are still not pin sharp. Even if you do not need to wear spectacles all the time it could be that your eyesight is not good enough to judge the point of sharpest focus in the camera viewfinder. When you look 'through' the viewfinder of an SLR, you are in fact examining a small ground glass screen through a magnifying system. The eyepiece on the back of the camera viewfinder is a small magnifying glass focused on the viewing screen. It is designed for people with normal vision or slight short-sightedness. Long-sighted people can often focus at close distances (about 1 metre). Short-sighted people cannot focus on distant subjects. Both groups can, however, normally focus on a subject between 1 and 2 metres away. Viewfinders are therefore set up to simulate this distance, but this may not work for you if you are extremely long- or short-sighted.

Also mild astigmatism, another common slight defect, can make it impossible to see enough detail for precise focusing. You can check whether you are suffering from inability to focus on the screen.

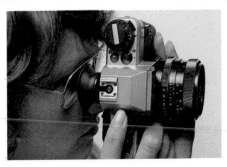

Checking eyesight: remove the lens and shine a domestic light bulb into the camera from about 1 metre away. If your eyesight is adequate the finely-grained surface of the screen should appear sharp, and the edges of any focusing aids should look clear and crisp.

Wearing spectacles: you should be able to see the whole screen when wearing spectacles for general use (not reading glasses). Fitting a rubber eye-cup to the eyepiece (above) makes viewing comfortable. If necessary, move your eye from side to side to ensure you see the screen edges.

Contact lenses: focusing should be easy with contact lenses although the detail may not appear quite as fine. You may find it easier to focus with a split-image prism rather than a microprism circle.

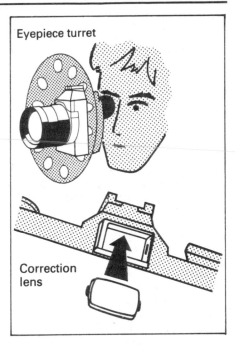

Eyepiece turret

Correction lens

CORRECTION LENSES

Long- or short-sight correction lenses (from camera distributors or opticians) can be fitted to most SLR eyepieces to remove the need for spectacles. An eyepiece turret shows the correction needed.

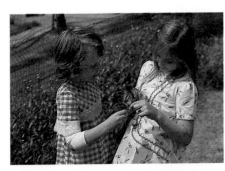

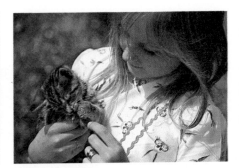

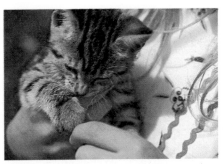

USING YOUR FOCUSING RANGE

Most 50mm SLR lenses focus down to between 30cm and 60cm from the subject; 45cm is the most common limit. Try to use the close-up range for effective, detailed photographs. Focusing accuracy is more critical the closer you are to the subject. At 45cm away, only 5 or 6cm depth in the subject will be sharp at medium apertures (around f8). How close you can afford to go depends on the depth of the subject and whether or not it is moving. The picture above was taken over 1 metre away from the girls. The girls could move freely, and even if the kitten had moved it would have been in focus.

Moving in closer: In this shot, taken from about 60cm away, there is still leeway for small subject movement or a small focusing error. The camera had to follow the subject all the time to keep it framed and focused correctly. With this type of close shot it is easier to move the camera slightly backwards and forwards rather than to keep changing the focusing ring should the subject move. To preserve your chosen composition keep the focusing distance constant rather than changing the setting on the focusing ring. The whiskers of the kitten make a good test for sharp forms in this particular picture.

Minimum focusing distance: For this shot the camera was set on its minimum 30cm focusing distance and the camera was moved to and fro until focus on the kitten became sharp. By now even a sudden move by the kitten would produce a blur. Note how the girl's hands are blurred. For shots like this you must view the focusing screen critically and learn to react quickly. With SLRs there is little risk of taking a picture closer than the minimum focusing distance allows because you can clearly see through the viewfinder that the image is blurred. Always decide on the main subject first, frame up a rough composition, focus carefully, then finalize composition. There is no remedy for unsharp pictures.

How the aperture affects focus:4

The aperture has two main functions:
a) to control how much light reaches the film in order to produce the correct exposure (see sections 7, 8 and 9), and
b) to control how much of the picture is in sharp focus.

Here we explore how the aperture affects depth of field, and how to choose the right f stop to create a picture that is either sharply focused throughout or only sharp in parts.

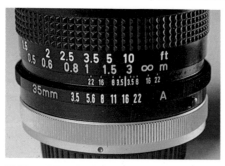

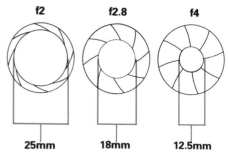

DIAPHRAGM AND APERTURE
Inside the SLR lens is a diaphragm made up of a circle of overlapping blades which produce a central round hole of variable diameter. This hole is called the aperture, and its size is given in f stops. Whenever we talk about aperture in photography we mean *effective* aperture: that is, the diameter of the beam of light allowed to pass through. This can change according to where the diaphragm is inside the lens. The *actual* diameter of the diaphragm is of interest only to lens designers.

You cannot measure the true diameter of your lens aperture because it is behind at least one glass element, which distorts the size. Of course, you can see it open and close. The iris does not have to be circular, though it nearly always is.

THE APERTURE SCALE
Your standard lens probably has at least seven apertures marked on its scale. These are drawn from the accepted series which progresses from f1 to f1·4, f2, f2·8, f4, f5·6, f8, f11, f16, f22, f32, and so on. Each number is one full f stop from each of the numbers next to it. Manufacturers like to have the largest possible maximum apertures on their lenses so often the maximum value does not coincide with an f stop from the scale. Values like f1·7 and f1·8 are common, and the lens shown here starts at f3·5. The step from the maximum aperture to the first f stop in the standard series is often less than one full stop. (In the case shown, f3·5 to f4 is a difference of only 1/3 stop.) Most aperture rings click-stop at each full f stop setting.

HOW f STOPS WORK
The f number describes the size of the aperture formed by the diaphragm blades in the lens. The number represents the focal length of the lens divided by the diameter of the aperture, so a 50mm lens with an aperture diameter of 25mm (50 ÷ 25) has an aperture value of f2.

However, the amount of light the aperture lets through depends on the *area* of the hole, not simply the diameter. If we halve the area of the f2 aperture, the diameter is 18mm and the aperture 2·8: f2·8 lets through half as much light as f2.

Each full f stop along the scale doubles or halves the amount of light allowed through. The larger the f number, the smaller the aperture .

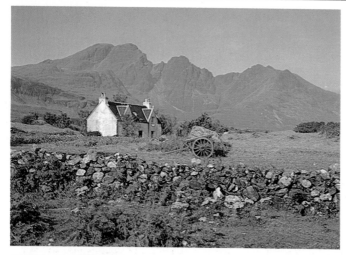

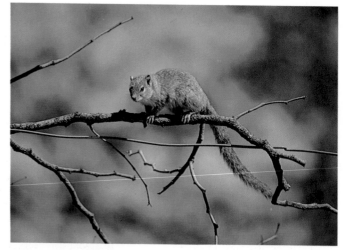

SMALL APERTURES
Small apertures such as f11, f16 and f22 give great depth of field. This means that most of the scene will be in focus—useful when you want both the foreground and the background to be sharp, for photographs of landscapes, city views and buildings. With shots of moving subjects a small aperture provides enough depth of field to minimize the effect of slight focusing errors. Small apertures are especially useful with close-up pictures where it is difficult to keep all of the subject in focus.

WIDE APERTURES
Wide apertures such as f2, f2·8 and f4 give shallow depth of field. This means that only objects just in front of or just behind the point on which you have focused are sharp. Objects closer to the lens or farther away will be out of focus and therefore unsharp. Careful focusing is therefore critical.

A wide aperture is useful for subjects like portraits and wildlife shots, as it helps to separate the subject from a potentially confusing background. Wide apertures can also be used to 'lose' intruding objects close to the lens such as wire netting.

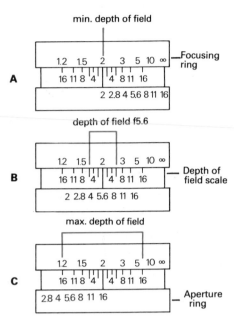

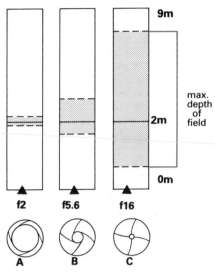

DEPTH OF FIELD

The human eye appears to see everything in sharp focus, but the camera lens is more selective. The lens can create a picture which is sharp virtually throughout, or limit sharpness to only part of the scene. Depth of field describes the extent of the scene which is sharp in front of and behind the point on which you have focused. Depth of field is controlled mainly by aperture size—small apertures give more depth of field; large apertures give less.

As shown above focusing on one flower and using a large aperture puts out of focus both the flowers closer to the camera and those farther away. As a rule of thumb, 2/3 of the depth of field will be behind the point of focus and 1/3 in front.

DEPTH OF FIELD SCALE

The depth of field scale on the lens indicates how much of the scene will be sharp at a given aperture.

In the diagram above, the f stops are marked on the aperture ring of the lens. Some of these numbers are repeated on the depth of field scale. With the lens set at f16 and focused on 2 metres the two '16s' on the depth of field scale lie opposite 1.2 metres and the equivalent of 8 metres on the focusing ring. This means that the part of the scene between 1.2 and 8 metres away from the camera is in focus, even though the lens is focused on one specific point. Therefore depth of field is 6.8 metres with these settings. Compare this with the much narrower depth of field for f5·6 and f2, shown above.

USING THE VIEWFINDER

When composing your picture and focusing, you will find it best to use the SLR viewfinder with the lens at maximum aperture. This setting gives the brightest screen image so you can see clearly. As focusing at wide apertures is critical, it will also ensure that you focus carefully.

But beware! The wide aperture also means that only part of the scene in the viewfinder will be in focus. The background may look unsharp, or an intrusion just in front of the lens may be sufficiently out of focus to be invisible. At the correct aperture for the shot the picture may be spoiled by something obscuring the lens or a distraction in the background which you had not noticed.

BACKGROUND INTRUSION

Small apertures such as f11 or f16 bring more of the picture depth into focus, but sometimes this can be a disadvantage. The sharp background may conflict with the subject as in the picture above, or accidental intrusions in front of the lens may come into focus.

To avoid these problems, choose an aperture wide enough to limit the depth of sharp focus. Or if you have a depth of field preview button, use it to check the effect of stopping down before you take the picture.

DEPTH OF FIELD PREVIEW

Many SLRs have a depth of field preview button (arrowed). When pressed, this temporarily closes down the aperture so you can see the depth of sharp focus (as seen by the lens) in the viewfinder. The screen darkens, but usually you can still assess the effect.

Some lenses only have a manual diaphragm, where turning the aperture ring actually closes or opens the blades. This means you are obliged to preview the depth of field as the lens sees it. Compose and focus at maximum aperture then stop down, ie turn to the correct smaller aperture, to take the shot.

The focal plane shutter is an intrinsic part of an SLR camera. It is positioned behind the mirror, about 1 or 2mm in front of the film (just in front of the focal plane) and it controls the amount of time that the film is exposed to light. The main job of the shutter is simple. When it is closed it keeps out light. When the shutter release button is pressed the shutter opens and exposes the film to light. The longer it remains open the more light reaches the film. Focal plane shutters are better at stopping action and achieving high speeds than the inter-lens types in non-reflex cameras but, to get the best out of them, it helps to understand how they work.

HOW THE SHUTTER WORKS

Most focal plane shutters consist of two blinds or curtains. These are made of special light-proof black cloth or, sometimes, metal. The cloth type run horizontally across the film plane from left to right. Metal shutters usually travel vertically.

When the shutter release button is pressed the first blind begins its travel, uncovering the film and exposing it to light. To end the exposure the second blind quickly follows the first and completely covers the film. When you

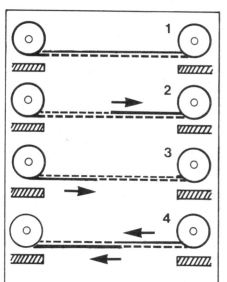

1) The closed shutter. 2) The first blind begins its travel. 3) The second blind follows. 4) Both are wound back.

wind on, both blinds are pulled back across the film to their original position—overlapping to keep out light. At the same time the springs are tensioned ready to propel the blinds forward when the shutter release button is pressed for the next exposure.

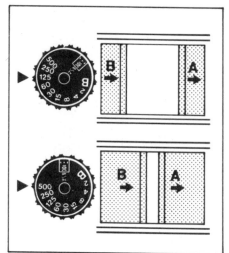

SHUTTER SPEEDS

The width of the gap between the two blinds is programmed by the shutter speed you choose. The slower the shutter speed, the later the second blind will follow the first and, therefore, the wider the gap between them. The diagram above shows the width of the gap when the shutter speed dial is set at 1/125 (top) and the difference in width when the shutter speed is set at 1/500 (bottom).

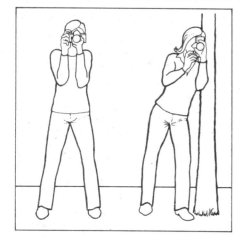

STANCE

If you are not properly balanced while taking a picture you are most likely to move the camera during the exposure. This will be most noticeable at slow shutter speeds, but you should get into the habit of always standing correctly. Imagine yourself as a human tripod. Find level ground and stand firmly with your legs slightly apart. For extra support lean against a tree or a wall, holding the camera against the upright surface.

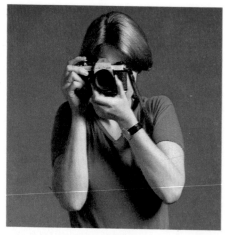

HOLDING THE CAMERA

It is also important to hold the camera as steady as possible. Support it in the palm of your left hand, leaving your fingers free for focusing. This helps to prevent downward movement when you release the shutter. Your right hand should grip the side of the camera firmly while your index finger works the shutter release. Remember: always keep your elbows tucked in—it is much easier to keep your hands steady if your arms are not moving!

USE A CAMERA BRACE

Another way to steady the camera is by continued upward tension. All you need is a length of light chain or non-stretch cord attached to the camera tripod screw with a spare tripod bush. The brace should be long enough to allow the camera to be held comfortably at eye-level with a loop or a short length secured under your foot. Pull gently upwards until the brace becomes taut. Continue to pull firmly while you press the shutter release button.

Hold the camera at eye-level

Pull gently upwards

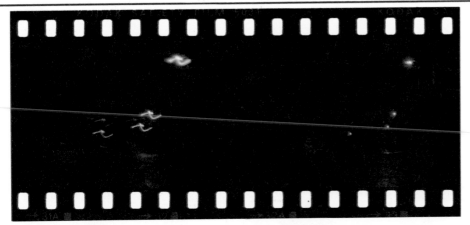

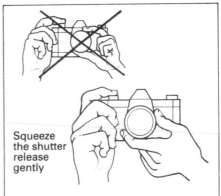

Squeeze the shutter release gently

CAMERA SHAKE
Using a shutter speed slower than 1/60 of a second when hand-holding the camera increases the chances of your picture suffering from camera shake. No matter how steady your hands, it is almost impossible to prevent some movement. The act of pressing the shutter release button is likely to create slight downward movement, while both the swing of the mirror and the travel of the shutter blinds can cause vibration. The result will ultimately be loss of sharpness in your picture.

TEST YOURSELF
If you really don't believe that your hands shake while holding the camera, try this simple experiment. Go outside one evening, after the street lamps have gone on, and take pictures of some of them. Use different shutter speeds, preferably throughout the range. At slower speeds the light from the lamps will faithfully trace out any camera movement (above left). The results will show at what speeds it is safe for you to hand-hold the camera without getting camera shake. The shutter speed for the picture above was 1/60 second.

RELEASING THE SHUTTER
There is only one way to operate the shutter release button correctly, and that is to squeeze slowly. If you jab at it the camera will move. Rest your finger on the button and, slowly and gently, squeeze down on it almost as if you were were pressing the trigger of a gun. Keep your finger pressed down until the exposure is complete.
You may find that it helps to take a deep breath just before pressing the shutter release button, and to hold your breath while taking the picture. Even the slight movement of breathing can contribute to camera shake.

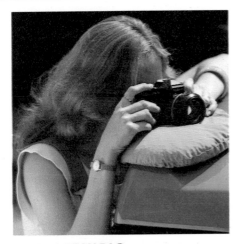

CARRY A BEAN BAG
A bean bag is a useful accessory for steadying the camera. It can be placed on almost any support and pushed into the right shape for the camera. This means that you can rest the camera on railings, cars or tree trunks without risk of damage. Bean bags are easy to make or can be bought cheaply. They are also easy to carry about with you. If you don't have one, you can use a rolled up jumper or towel as a substitute in an emergency.

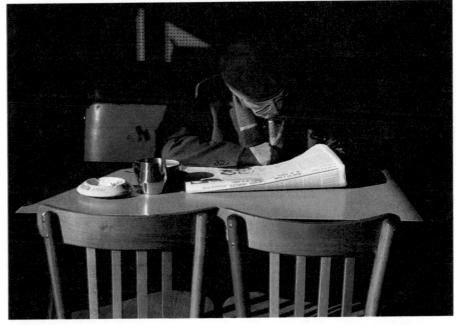

WHY BE SO CAREFUL?
The size of the picture above is about average for a normal print, and yet it is about 12 times bigger than a 35mm slide or negative. This means that any slight degree of blur, which you may not even see on a 35mm slide but which the film will have faithfully recorded, will be 12 times more noticeable on a print this size. Even worse, if you project a slide the image may be 120 times bigger—and so will the mistakes! So it is worth taking the extra trouble to ensure your pictures are sharp.

Shutter speeds and moving subjects:6

As explained in section 5 of this Course, the main function of the shutter is to control the amount of time that the film is exposed to light. Its second function is to determine the way in which movement is recorded.

If the subject being photographed moves while the shutter is open, blur will be recorded on the film. The amount of blur will depend on two things—how fast the subject is moving and how long the shutter remains open. The faster the speed of the subject and the slower the shutter speed, the more blurred the image will be.

Usually you will want to freeze action completely. Other times you may prefer to have some streaks or blur just to show how fast something in the picture is moving. The choice is yours.

STOPPING MOVEMENT

Most cameras have a range of shutter speeds from 1 second to 1/1000 second. To eliminate movement, or to 'freeze' the subject in mid-motion, you must use a fast shutter speed. With the shutter open for only a split second the subject has no time to move across the picture area and cause a blurred image. For most moving subjects shutter speeds in excess of 1/250 are needed to freeze action.

A SLOW SPEED

When lighting conditions are poor you will have to use a slow shutter speed. You cannot then stop subject movement and so must either accept blur or use a static subject. The shutter speed used here was 1/8.

A FAST SPEED

To stop subject movement you will have to use a fast shutter speed. Just how fast will depend on the speed of subject movement in relation to camera position (see table). For this shot the shutter speed was 1/1000.

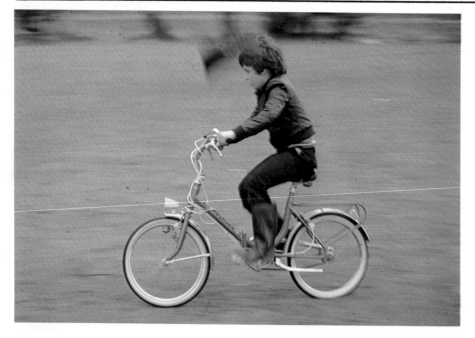

PANNING

If you use a slower shutter speed you can still get a sharp picture of a moving subject by following the movement with the camera while pressing the shutter release button. This is known as panning and is often used in sports photography.

By moving the camera so that the subject is kept in the same place in the viewfinder all the time the shutter is open you will get good subject sharpness. The background, however, will record as blurred, giving a strong impression of speed.

HOW TO PAN

Stand firmly, and pre-focus on the spot where you plan to take the picture. Turn towards the oncoming subject and follow it. Press the shutter release, but keep following the subject until after the end of the exposure.

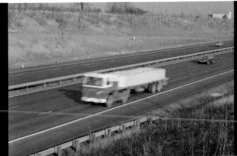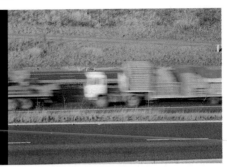

SPEED AND MOVEMENT

The exact effect of subject movement depends on how far the camera is from the subject and the direction in which the subject is travelling.

The pictures above were all taken at a shutter speed of 1/30. The degree of blur is much more pronounced when subject movement is directly across the camera (right) than when the movement is head on (left). When subject movement is at 45° to the camera (centre) the amount of blur recorded is somewhere between the two.

Use the simple table shown here as a guide to the shutter speeds required to get a sharp picture of subjects moving at different speeds and at various distances from the camera.

Subject at	Pedestrian (5 km/h)	Runner (15 km/h)	Cyclist (25 km/h)	Horses (40 km/h)	Traffic (65 km/h)	Train (120 km/h)
1 m	1/1000	1/2000				
3 m	1/500	1/1000	1/2000			
5 m	1/250	1/500	1/1000	1/2000		
10 m	1/125	1/250	1/500	1/1000	1/2000	
30 m	1/60	1/125	1/250	1/500	1/1000	1/2000

The shutter speeds given above are for subjects moving directly across the picture area. For subjects moving at an angle of 45° to the camera you can use the next slowest shutter speed and still get a sharp picture.

If the subject is moving directly away from or towards the camera two speeds slower than the shutter speed given above can be used.
When panning, experiment with speeds faster than 1/30 of a second.

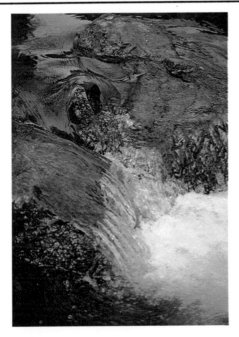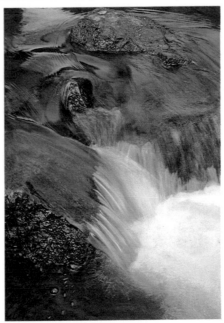

SHARP. . .
The camera is unique in its ability to freeze movement, and provides an unequalled opportunity to study precise detail in a moving subject. The shutter speed used for the picture above was 1/1000.

. . . OR BLURRED?
Pin-sharp motion shots can look dramatic but they may also seem rather artificial. In this picture the slower shutter speed of 1/8 gives a greater sense of the flow of rushing water.

CREATIVE BLUR
When a slow speed is used a moving subject can be so blurred it almost disappears, while motionless parts record as usual. This shot of an athlete's foot was taken at 1/8.

The exposure controls on an SLR camera are the aperture ring and the shutter speed dial. Together they work to control the amount of light which reaches the film. It is light falling on the light-sensitive emulsion of the film which makes the exposure.

When light reaches the film it begins to turn the emulsion black. More light comes from the brighter areas of the subject and so these form the blacker parts of the film; the darkest areas of the subject reflect the least light and so are recorded as light areas on the film. As a result, the film produces a tonally 'back-to-front' *negative* image. When a print is made this negative is converted into a positive image.

To get the *correct* exposure—that is, a final picture which shows a full range of tones—the film must receive the right amount of light. Too little exposure to light will produce a thin negative and so a dark print; too much exposure will produce a dense negative and the final image on the print will be too light. Conversely, thick and dense transparencies are the result of too little light while thin, bleached-out slides are produced by excessive exposure. Even experts 'bracket' exposures, that is, expose extra frames differently.

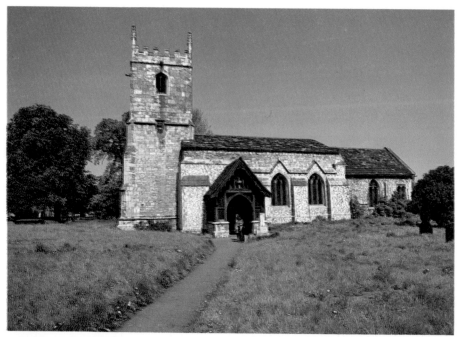

CORRECT EXPOSURE

In a print from a correctly exposed negative, the darkest shadow areas of the subject reproduce as a full black, and the lightest highlights as clear white, with a full range of tones (greys and shades of colour) between.

The picture above is correctly exposed. The highlight areas in the walls of the church print as clear white. The darkest shadow areas, are solid black. The roof, trees, grass and flowers clearly show a range of tones and shades of colour.

CONTROLLING EXPOSURE

As already mentioned, to control the exposure you must control the amount of light falling on the film. There are two ways of doing this. The first is to vary the size of the aperture, and so control the *intensity* of the light passing through the lens. The second is to alter the shutter speed setting and so control the length of *time* for which light falls on the film emulsion. A combination of these two controls determines the exposure.

You can get the same exposure from a range of aperture and shutter speed combinations. These diagrams show that a wide aperture used in conjunction with a fast shutter speed (f2·8 + 1/1000) will give the same amount of light, and so the same exposure, as a small aperture and a slow shutter speed (f11 + 1/60). With an aperture of f5·6 a shutter speed of 1/250 will also give the same exposure. The yellow panels on the far right all represent the same exposure from the same subject. The left-hand column represents the intensity of light passing through the lens at various aperture sizes and the middle column shows light allowed through at various shutter speed settings.

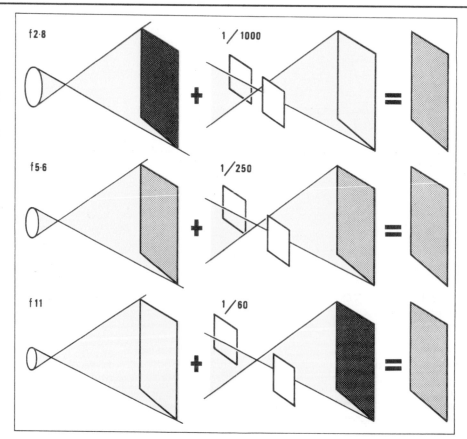

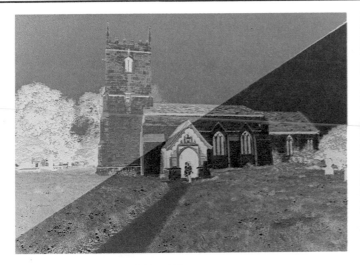

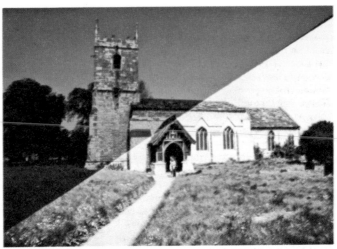

BADLY EXPOSED NEGATIVES

A negative can be incorrectly exposed in two ways. If too much light reaches the film, the emulsion turns too black and the negative is over-exposed. If too little light falls on the film not enough of the emulsion is turned black and the negative is under-exposed. An under-exposed negative (top left half, above) looks thin and 'washed out'. There are clear areas where parts of the dark subject have not been recorded. An over-exposed negative (bottom right half) looks thick or dense and 'blocked up'. The light areas of the subject may be so dense on the negative that detail is lost. Excessive over-exposure may also produce a grainy, unsharp image. (Most colour negatives have this orange-pink look.)

PRINTS FROM BADLY EXPOSED NEGATIVES

Given the same printing exposure, a thin, under-exposed negative will give a very dark print, while a thick, over-exposed one will give a thin, light print. Changing the printing exposure to compensate can improve the results, but you can't 'put back' detail which has not been recorded on the original negative. For example, the top left half of this picture, from the under-exposed negative, lacks detail in the shadow areas and the mid-tones are hard to distinguish. The bottom right half, from the over-exposed negative, is washed out, and the light areas are lacking in detail. (An over-exposed colour slide will also be washed out and lacking in detail.)

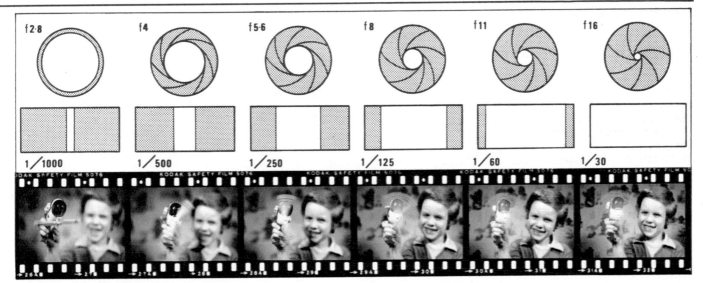

COMBINING SHUTTER AND APERTURE

For most lighting conditions there is a range of shutter speed and aperture combinations which will give correct exposures. What you have to remember is that if you close down the aperture by one stop you halve the amount of light that it lets through. To obtain the correct exposure at this smaller aperture you must therefore use the next slowest shutter speed to double the time for which the film is exposed to light, and so compensate for the loss of intensity. Above are six combinations giving the same exposure.

ONE EXPOSURE, SEVERAL CHOICES

Although it is possible to get the same exposure using a number of different combinations, as the strip of pictures above illustrates, the effect on depth of field and movement will vary. The combination you choose will depend on the effect you want to produce. If you want to freeze fast movement you must set a fast shutter speed first and then adjust the aperture to provide the correct exposure. If you want to control depth of field set the aperture first and then adjust the shutter speed for the correct exposure.

Using your camera's exposure meter:8

Almost all modern SLRs have an exposure meter built into them. These meters are battery powered and use one or two light-sensitive cells to measure the amount of light coming through the lens. Hence they are called 'through-the-lens' or TTL meters.

These meters are easy to use because they are coupled to the camera's shutter speed dial and aperture ring. Taking the light reading involves setting the correct exposure on the camera, instead of these being separate actions, as they are with hand-held or clip-on meters.

TTL meters come in two different types, stop-down and full aperture. Stop-down meters measure the light with the lens closed down to the taking aperture set on the lens. Full aperture meters measure at the maximum aperture of the lens but (as long as the lens has the correct linkages with the camera body) make an allowance to compensate for the smaller aperture actually set. Stopping the lens down darkens the viewfinder, so full aperture metering is better.

Some cameras have special 'spot-metering' systems which measure exposure from a small, selected area of the subject. Usually this spot system is optional and can be switched over to the overall or 'integrating' type.

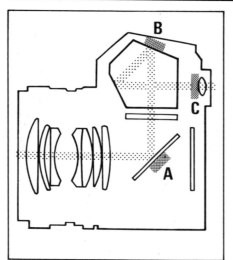

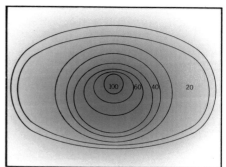

METERING CELLS

The metering cell or cells may be sited in one of three main positions in order to measure the light on its path from the lens to your eye (see dotted band in diagram). These are (A) on or behind the surface of the mirror, (B) in the top of the prism, or (C) next to the viewfinder eyepiece. The positioning governs the weighting of the light reading, and also the extent to which the meter can be misled by light entering through the viewfinder eyepiece.

WEIGHTING

A TTL meter can measure all the light coming through the lens and give an average reading, or measure the central spot where the subject is most likely to be placed. *Average* metering works well with average scenes. *Spot* metering works best for difficult subjects. Most TTL meters take most notice of the centre of the frame. This gives 'centre-weighted metering', which is illustrated in the diagram: the strength of the colour shows the degree of meter sensitivity. As the top of the picture often contains sky, many cameras have meters where the main area of sensitivity is below the centre, or 'centre-bottom weighting'.

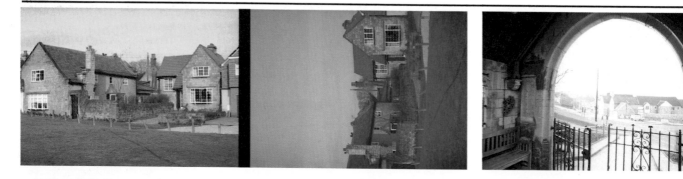

HOW WEIGHTING WORKS

Camera manufacturers have found that most pictures are taken with the camera held horizontally, with the subject placed in the centre of the frame, towards the bottom. The main subject is what you want to be correctly exposed, so it makes sense to have the TTL meter pay most attention to this area when measuring exposure. The result is a 'centre-bottom weighted' metering pattern. It works perfectly with average subjects, such as the house in the picture above, where the main area of subject interest coincides with the metering pattern.

WHERE WEIGHTING FAILS

Weighting fails when the meter's area of sensitivity does not correspond exactly to the subject, as in the picture above. The same house has been photographed in the same lighting, so logically the exposure should be the same. But with the camera turned for a vertical shot, part of the sensitive 'centre-bottom' area is reading a patch of sky. It has responded to the extra brightness by closing down the aperture, thus under-exposing the main subject. In such cases, it is best to take a meter reading with the camera horizontal before turning it for a vertical shot.

DIFFICULT SUBJECTS

A TTL meter is calibrated to give correct exposure for a mid grey tone. This works with coloured subjects containing a wide range of tones because if you mix them all together the result is, on average, a mid grey tone.

However, where a subject is divided into clearly separated dark and light areas, this assumption may not be valid. In the picture above, the meter has given an average reading for the bright subject in the centre and the dark surround. The result is that the centre is over-exposed and the surrounding arch under-exposed.

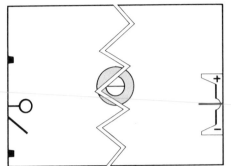 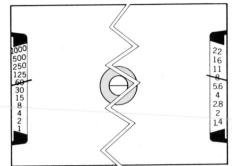 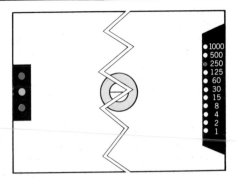

VIEWFINDER DISPLAYS

There are many types of display to show the meter reading in the viewfinder. Moving needle displays are common.

Match-needle systems (above left): the meter needle swings up and down according to the amount of light being measured. You adjust the speed or aperture until a second needle (usually with an 'O' end to assist alignment) is positioned over it for correct exposure.

Centre-needle systems (above right): the needle swings up and down as before. You adjust shutter speed or aperture to centre the needle between two marks to obtain correct exposure.

With displays like the two above, there is usually no indication of the actual values of shutter and aperture set.

SCALE READINGS

A refinement of the match-needle system is to have the needle move over either a shutter speed scale or an aperture scale on one side of the viewfinder. The other value (either the aperture or the speed) may be shown elsewhere in the finder.

Aperture priority (above left): with the aperture set, the needle points to the speed required for correct exposure.

Shutter priority (above right): with the speed set, the needle points to the aperture required for correct exposure. In each case, the photographer sets one of the exposure values manually. With auto-exposure SLRs, however, this is performed automatically.

LED DISPLAYS

Needle displays are delicate and prone to mechanical failure, especially if cameras are dropped. Many electronic cameras now use LEDs (light emitting diodes) instead, but in practice these are used in the same way.

Centering systems (above left): simple LED systems work just like centre needle ones. Usually two red LEDs are used to show under- or over-exposure, and a central green LED lights up for correct exposure.

Scale systems (above right): these use an LED for each shutter speed, and work just like aperture priority systems: the LED next to the correct speed lights up. LEDs are less prone to mechanical failure and are easier to see in the dark.

SELECTIVE METERING

In this problem picture, the choice was between (1) giving correct exposure for the surrounding arch, allowing the centre of the frame to be over-exposed; and (2) giving correct exposure for the central subject, letting the archway be under-exposed. For the picture above, the second alternative was chosen. Whichever the choice, the method is to use the camera to take a meter reading from the main subject *only,* setting or holding that exposure, then returning to the original composition to take the shot. This is called 'selective metering'.

BACKLIGHTING

The most common situation requiring selective metering is when taking portraits with the subject positioned 'against the light', or against a bright area such as a patch of sky. The meter has no way of knowing what the main subject is, and sets the exposure to take into account the bright background. It therefore sets either too fast a shutter speed or too small an aperture. The result is shown in the picture above— the subject's face comes out under-exposed—too dark in the picture. There are three ways to correct this problem.

BACKLIGHT CONTROL

To get correct exposure: (1) If you have a spot meter, use it to take a reading from the face only. (2) With an averaging meter, go up to the subject and take a close-up reading from the face. (3) Take the reading normally but override the meter by opening up an extra 1½ to 2 stops to compensate for the back-lighting. Many automatic SLRs have overrides for this purpose: you simply set x2 on an exposure compensation (EV) dial. Some automatic SLRs have a push-button 'backlight control' which provides 1½ stops extra exposure automatically, as above.

When you have been using a TTL (through-the-lens) or hand-held meter for some time you will find that you can often predict the correct exposure simply by looking at the scene you want to photograph. This isn't because your eyes can accurately judge the intensity of light—on the contrary, they adjust to it so that you can see just as easily on a dull day as on a bright one. The reason is that you learn to recognise certain weather conditions as being appropriate to particular exposure settings.

There are advantages in being able to predict the correct exposure. The first is that if by some chance your meter is giving inaccurate readings (perhaps the battery is run down) you will be able to tell. If on a sunny day, for instance, your meter tells you the correct exposure is f4 at 1/60 you can be fairly sure that something is wrong—either the ASA speed is set wrongly, or the meter is faulty, or the subject is in very unusual lighting. In any case, you must make some correction. Often you can look at the weather and say, 'This is a 1/250 at f5·6 day, with 100 ASA film' and be right. Of course, light variations and unusual subjects, such as those which are back lit, need alterations to the basic setting but you can learn very quickly.

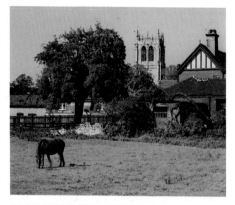

SAFE EXPOSURE SETTING
Simple cartridge cameras often have only one setting but still produce good results on bright days. A manual SLR can be set in the same way to give exactly the same chance of usable exposures. This can be useful when you need to shoot very quickly, or for a beginner.

Just set the camera at 1/250 at f8 if using medium speed film or 1/500 at f11 for fast film. This 'safe' setting is most suitable for use with negative films for prints (slides need more accurate exposure). The success rate with simple snaps is higher than you might expect.

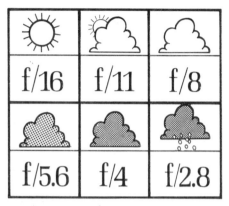

ESTIMATING EXPOSURE
The table above is universal and you can use it for estimating exposure with any make of film, as long as you know the ASA speed. Set the shutter speed to the nearest setting, numerically, to the ASA film speed (not DIN film speed). For a 400 ASA film use 1/500, for 100 ASA use 1/125, for 64 ASA use 1/60. Now just read off the aperture underneath the appropriate weather symbol. Open up by *one extra* f stop in winter, *one extra* 1-2 hours from sunset or sunrise, and *one extra* for dark subjects or close-ups (add the extra f stops together for these in combination).

DEALING WITH DARK BACKGROUNDS
If the greater part of the picture is dark, but the camera's meter reads from the whole scene, it will try to give too much exposure to compensate for the lack of light in the background. Unless you want this dark area to record lighter you have to adjust the indicated exposure by cutting it down—giving one or two stops less exposure or using a faster shutter speed. The picture will then have a rich, dark background on which a correctly exposed subject stands out, rather than a grey, washed out background with a burned-out detail-free subject. On cameras with exposure compensation dial − 1. Ideally, you should take an exposure reading from close to the subject, excluding the background.

DEALING WITH LIGHT BACKGROUNDS
If you have a fairly dark subject against a much brighter background the reverse happens: the meter receives too much light and indicates less exposure than is needed. If this reading is followed the result will be a picture with a grey background and a very dark subject with no detail. So, you should increase your exposure, much as you would for back-lit subjects. You can do this by using a backlight control button, an exposure over-ride dial set to + 1, or, again, by taking a close-up reading from the subject only. If the two scenes above had been lit the same, the exposure needed would have been the same. The meter reading, however, would have shown at least two stops difference.

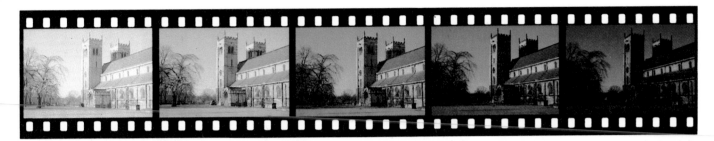

BRACKETING

Once you get to know the kind of exposures to expect there will be times when the meter reading seems to disagree with common sense. This happens most often in difficult light and you may then have to rely on guesswork. Bracketing is the simplest solution to any doubts about exposure accuracy. As in the strip above, you take a number of shots instead of one. The correct exposure might be one stop more or less than the indicated exposure. By making three exposures, including one at one stop more and one at one stop less than the meter reading, you can be fairly sure of a usable result. If in real doubt, you can make more exposures, or even bracket at half-stop intervals. Professionals do this to guarantee maximum exposure accuracy.

LATITUDE

Look again at the strip above and you will see that the central three exposures are all fairly good. In fact, detail is visible in all five of them, although the densest shot received only 1/16th of the exposure of the lightest one. The film can thus cope wih a reasonable amount of exposure error, and the ability to do this is called *latitude*. With films for prints, variations in exposure of one stop under the right setting or two stops over can be corrected undetectably during printing.

The strip above was taken on colour slide film, where there is no chance to correct exposure afterwards, but the central three slides are all usable. So, bracketing and natural film latitude make estimating exposure a better risk than you might otherwise expect.

FILM ECONOMY

If you took a strip of five exposures for each subject you would be wasting film, so wholesale bracketing is not a good idea. By using experience and common sense, you should be able to guard against exposure error by taking a maximum of one additional shot. Only bracket if the subject is unrepeatable, vitally important, or if you think the meter reading is inaccurate. With slide films bracket at half-stop intervals. With print films bracket at full stop intervals. For extra economy, in general with slide films bracket only on the side of *under*-exposure, and with print films only on the side of *over*-exposure, as this ensures detail is retained as far as possible. Unless the lighting conditions are very difficult, one of the exposures should be correct.

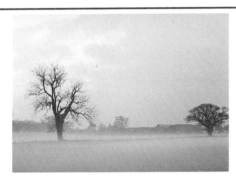

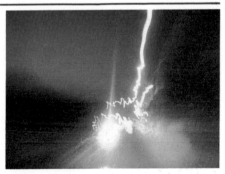

DELIBERATE OVER-EXPOSURE

If the subject is predominantly light and not too contrasty it may benefit from a light and delicate rendering. Try giving two or even three stops of deliberate over-exposure. This will soften the colours and produce a soft, atmospheric picture.

Results are best when the important detail of the subject is in the mid-tones and darker parts of the picture. The lighter areas are certain to lose detail. Suitable subjects include snow scenes, where the TTL meter reading will expose to give snow *grey* tones instead of whites, and make landscapes bathed in early morning mist look like the picture above.

DELIBERATE UNDER-EXPOSURE

Subjects in bright light can often benefit from a half or whole stop under-exposure. This increases the saturation of the colours and produces a richer, more dramatic picture. It also gives solid, black shadows, so if you want to retain important detail in shadow areas this technique is obviously unsuitable. It works best with strongly lit, textured, solid subjects with definite highlights containing important detail. The picture above was under-exposed by one stop to ensure maximum colour saturation. Under-exposure loses details in shadow areas but improves the rendering in the highlights.

TIME EXPOSURES

The 'B' setting on your camera's shutter speed dial holds the shutter open and allows you to give exposures of longer than one second. This is particularly useful in low lighting conditions or if you want to record blurred movement. Often these long exposures are beyond the range of the meter on your camera. You will therefore have to experiment in order to get acceptable results. Bracket each shot, and as a rule of thumb start by giving a *longer* exposure than you think you would need. For sharp pictures you must use a support.

The picture of car headlights above was taken from another car during an exposure of 2 seconds at f5·6.

The shelves of your local dealer may seem to display a bewildering range of different films. However, once you have chosen a brand, there are only three main types of film—colour negative, colour slide and black and white negative. Each has its own characteristics and the choice of a particular type or film speed depends on personal preference, the subject to be photographed and the lighting conditions.

COLOUR NEGATIVE

This film is used to produce colour prints. The cost of the film does not include processing, and there is a wide choice of process-and-print services available. Once the film is exposed you can return it to the dealer for developing and printing, send it away to a mail order process-and-print firm, or take it to a professional colour laboratory directly. Alternatively, if you have the facilities you can process the film yourself. Prints are made from the negative (above left) after the film has been developed. Prints from colour negatives are normally 85 x 125mm (enprint size) but the professional labs offer 180 x 125mm, and 200 x 150mm prints at higher cost.

COLOUR SLIDE (REVERSAL)

This film is for direct production of positive colour transparencies (above, centre) for projection. Some slide films include processing in their price (Fujichrome, Kodachrome, Agfa CT, Orwochrome, Boots, Dixons Prinzcolor). Others (Ektachrome, Fujichrome Professional, 3M) do not and must be returned to the dealer or a laboratory for paid processing.

According to the number of pictures you wish to take, you can choose from rolls of either 20, 24 or 36 exposures.

If you want copies of your colour slides you can have duplicates or even prints made. However, these are likely to be of poorer quality than the original and fairly expensive.

BLACK AND WHITE NEGATIVE

This is the film used to produce black and white prints. The price of the film does not include processing.

The chemicals and simple equipment required for processing black and white negative film are inexpensive and readily available from photographic dealers, so most black and white users do their own processing and make their own prints. Good results are not difficult to achieve, and this has led to a decline in commercial black and white processing, which is now often more expensive than colour. An example of a black and white negative is shown above right (all monochrome 35mm films have a tinted base, usually blue-grey).

FILM LIST (SLOW)

Colour neg—	There are no slow negative films currently made.
Colour slide—	Kodachrome 25 Agfachrome 50S Agfachrome CT18 Kodachrome 64 Ektachrome 64
Black & White—	Agfapan 25 Kodak Panatomic X EFKE KB17 and 14 Ilford Pan F

SLOW FILMS

Slow films (25 to 64 ASA) are less sensitive to light than normal, requiring wider apertures or longer shutter speeds to give more exposure. On very dull days or in dim light (dusk, interiors *etc*) the use of a tripod may be necessary. A typical exposure in bright sunlight with a 25 ASA film, the slowest normally used, is 1/125 at f8. With slow films you also have to use wider apertures for flash or restrict flash photography to close distances.

ADVANTAGES

Slow films give the best sharpness and detail, the finest grain, and are most suitable for making large prints provided the light is good, the subject does not move and the lens is sharp at wide apertures.

DISADVANTAGES

Because slow films require more exposure there is increased risk of camera shake and less potential for action shots in poor light. Slow black and white and colour films may also be rather high in contrast in bright sunlight.

FILM SPEEDS

All three of the main types of film are made in a range of film speeds. The speeds reflect the degree of the films' sensitivity to light and are usually marked in ASA numbers of between 25 and 400, or the equivalent in DIN (15-27). Each speed is appropriate for a different lighting condition.

The meter on your camera is linked to the film speed dial (above). Therefore, it is important that you set the right film speed before you begin to expose the film. When you have loaded a film in the camera, turn the film speed dial until the marker corresponds to the ASA/DIN number of the film you are using. The meter will then give correct readings.

FILM LIST (MEDIUM)

Color neg—

Kodacolor II	Agfachrome 100
Vericolor II	Agfacolor 80S
Fujicolor F-II	3M 100
N100	Ilfocolor 100

Colour slide—

3M Colorprint	Agfachrome CT21
100 Fujichrome	Ektachrome
RD100	200
Sakurachrome	Agfachrome
100	200
Ilfochrome 100	

Black & White—

Ilford FP4	Agfapan 100
Kodak Plus X	EFKE KB21

MEDIUM SPEED FILMS

Medium speed films (80 to 200 ASA) are intended for all types of photography, producing good results even in inexperienced hands. They are sensitive enough to light to be used on dull days, with small flash guns, and without a tripod in most conditions. In sunshine, 1/250 at f11 is a typical exposure.

PROS AND CONS

Medium speed films can cope with a great range of subjects and conditions, give good colour, fairly fine grain and have a good latitude to exposure error. They are really only inadequate in extreme lighting conditions.

FILM LIST (FAST)

Colour neg—	Kodacolor 400
	Agfacolor CNS 400
	Fuji F-11 400
	Sakuracolor 400
	3M 400
	Ilfocolor 400
Colour slide—	Ektachrome 400
	3M Colorslide 400
Black & White—	Kodak Tri-X
	Kodak Panatomic X
	Ilford HP5
	Agfapan 400

FAST FILMS

Fast films (320 to 500 ASA and over) are highly sensitive to light and allow very fast shutter speeds for stopping action, or normal shutter speeds for hand-held shots in low light. Flash exposures are often possible up to 10 metres away; subjects such as racing cars can be stopped with speeds like 1/1000; candid shots of people can be taken without flash in low light with an aperture of f2. A typical exposure in sunlight would be 1/1000 at f11, and 1/30 at f1·8 in candle light. Usual speed is 400 ASA.

ADVANTAGES

Pictures which cannot be taken with slow or medium speed films are often possible with fast film. Regardless of the light or weather, you are assured of the shortest possible exposure. Fast films go on working when others would need more light. The picture above was taken on a cloudy day but the 400 ASA colour negative film used permitted a shutter speed of 1/1000 to freeze movement. Fast colour negative films also cope well with different types of light—daylight, tungsten light or even fluorescent tubes—without producing a pronounced colour cast.

DISADVANTAGES

All fast films produce comparatively grainy looking pictures and have a limited ability to show very fine detail. Colour negative 400 ASA films are surprisingly good, and apart from graininess the only problem may be harsh colours in sunlight and inability to cope with high contrast. Colour slides on 400 ASA film may suffer some loss in definition. Fast black and white films can give 'greyer' results than other films, but for candid shots like the one above this can be acceptable. Latitude for exposure error is good with black and white and colour negative types, but not so good with colour slide film.

A wrongly loaded camera is worse than no camera at all. Although the film is 'in', you could be taking no pictures, or taking 36 shots on one single frame. Once the film is inside the camera it can be hard to tell if all is well. You can't open the back to look! So correct loading is vital.

More camera accidents happen during loading or unloading than at any other time. So, the first thing is to find a safe place to change films: a table-top, car seat or other clean surface. (Some outfit cases are good for resting the camera on.) A dropped film cassette may burst open, ruining the whole roll, so do not work at a height.

Normally the camera is rested on its lens, back upwards; you should always have the lens cap on and avoid rough surfaces. Sitting down comfortably and holding the lens lightly between your legs is one safe method. If possible keep the camera neckstrap round your neck for security.

Make sure the exposed roll of film is fully wound back before you open the camera back, and avoid touching the shutter while loading.

Make a note of the film type and the number of exposures on the cassette. It may be 36, 24, 20 or even 12. Better still, keep the end tab from a film carton as a useful reminder.

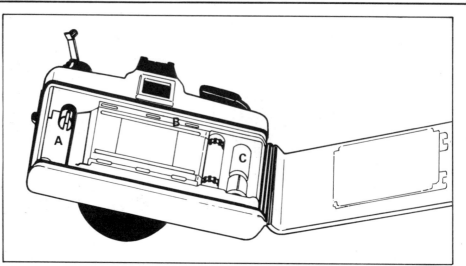

LOADING THE CAMERA

When loading, always work in the shade—preferably indoors. This minimizes the chances of bright light leaking through the velvet light-trap on the cassette and fogging the film.
Lift the rewind crank.
Hold the cassette with the opening pointing downwards. Insert the tongue of film firmly into the take-up spool (C). When this is gripped by the teeth, gently pull the cassette across the shutter and drop it in the chamber (A).

ENGAGING THE FILM

Tighten the take-up spool gently until the film leader sprocket holes engage the sprocket drive teeth. Make sure that both sides are engaged and that the film is accurately located between the guide rails (B).
Close the back and wind on twice, releasing the shutter for blank frames. Winding on only once risks a fogged first shot. As soon as you have loaded the film set the ASA speed on the dial, and set the frame counter to 'I'.

REWINDING THE FILM

Never try to rewind a film without first depressing the rewind clutch release button (above), usually on the camera base. (Some makes such as Olympus may have this on the top plate or front.) In most cases the button stays in once depressed, but in some makes you must keep your finger on it while rewinding.
Rewind slowly and smoothly and never try to overcome resistance (some cassettes may be stiff but there is a lot of difference between this and a jammed film). Turn the rewind knob clockwise. If you turn it the other way the film may be badly scratched and will be in the cassette emulsion-side out, risking more scratches later.

ALWAYS WIND BACK SLOWLY

Fast rewinding is to be avoided at all costs. Apart from a much greater risk of any dust particles getting drawn into the cassette and scratching the film, static electricity can be produced, attracting more dust and sometimes even making marks on the film.
Another reason for slow rewinding is that when you reach the point that the leader parts company with the take-up spool, you should hear a click as it leaves the slot. Open the camera back now and the leader will still be sticking out of the cassette. This makes processing much easier. If in doubt, however, wind back fully, then there is no risk of too much film sticking out and spoiling your last frame.

IDENTIFYING USED FILM

One of the worst disasters than can befall a photographer is to reload a roll of film that has already been exposed—thereby effectively ruining two sets of pictures.
To avoid this you can either a) rewind fully, so that the leader is wound right back into the cassette, or b) tear off the leader after rewinding. However, as leaving the leader out makes processing slightly easier it is better to mark the leader and/or the cassette clearly so that an exposed film is immediately identifiable.

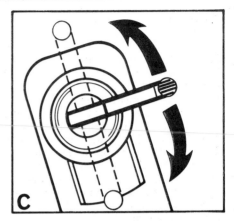

TAKE UP THE SLACK

If you have sudden doubts about whether your film is winding on correctly it is fairly easy to check. First, tighten the film in the cassette by winding back the rewind knob clockwise (see A above). Do not press the rewind release button on the bottom of the camera. You are not rewinding, just taking up any slack inside the cassette. As soon as you feel any resistance, stop winding. Noise from the cassette may indicate that you are over-tightening and rubbing the spooled film—risking scratch marks.

WIND ON AND WATCH

Having taken up the slack, take your next shot. Then wind on as normal. As you wind on, watch the rewind knob to make sure that it is turning. If it turns anti-clockwise (see B above) then the film is being transported correctly. After this, periodic glances at the rewind knob should show that it turns with winding on. Experienced photographers keep an eye on this all the time.

FRAME COUNTER PROBLEMS

Sometimes the film appears to reach its end before the frame counter shows 20, 24 or 36. There are four possible reasons for this happening: a) you have loaded a shorter film than you thought you had; b) you have lost frames by winding on too much film when loading; c) the frame counter is faulty; d) the film is jammed.
To find out if the film is genuinely finished, turn the rewind knob in both directions (see C above). If you can move more than half a turn either way there is still film in the cassette. Rewind, unload and check the camera.

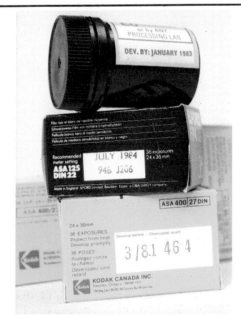

FILM EXPIRY DATES

Every box of film should have an expiry date coded or stamped somewhere on it. With black and white film this may be four years ahead, but with colour only one or two. This is the date before which the film should be used for optimum results.

HOME STORAGE OF FILM

Most films are intended to be stored at a temperature of about 20°C. If the weather is very hot you can keep film in a fridge—but let it warm up for two hours before you open the foil or plastic container. Otherwise condensation forms in the cassette.

AFTER EXPOSURE

Always get your film processed as quickly as possible. Mark all films clearly with your name and address. Mark any special processing instructions on a label and wrap it tightly round the cassette with a rubber band.

Good technique will always enable you to take good photographs, even when you use your SLR with just a standard lens. Technique, however, is not everything. Many picture opportunities are lost because of lighting problems, subject size or distance, and lack of camera support. A basic outfit of accessories helps to solve these commonly-met difficulties, and extends creative possibilities.

Lighting problems occur daily — or nightly. Modern fast lenses and films can deal with poor light reasonably well but also present technical problems. The results are generally not as good as those taken under ideal conditions.

The most convenient solution is to use flash. This freezes movement, precludes camera shake and provides light totally independent of existing sources.

Camera shake can be eliminated by using a tripod.

Space and distance, closely related to *subject size,* can be tackled by using additional lenses.

Colour and tone can be improved and controlled by the use of filters.

Special effects, such as multiple images or soft focus, can be produced by lens attachments. You can start with a basic outfit and gradually add extra items as required.

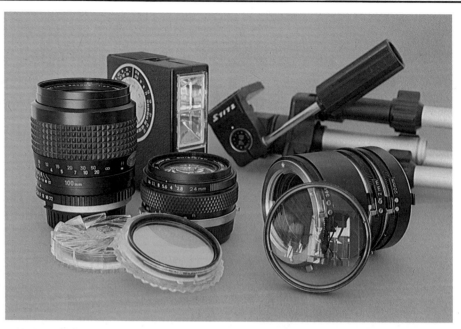

THE BASIC OUTFIT
Accessories like those shown above are available for all SLR cameras.

The flash gun is small enough to carry easily or mount on the camera top, but still gives powerful flashes of light. The tripod is also compact, but holds a normal SLR firmly.

Which **filters** you include will depend on the kind of pictures you take.

The **close-up lens** and **extension tubes** increase the close-focus capability of your camera.

The **telephoto** and **wide angle lenses** magnify distant subjects and gather in wider views respectively.

FILTERS
A filter is a piece of flat glass, or plastic, which screws into, or slips over, the front rim of a lens. It can be clear, slightly tinted or strongly coloured. The function of any filter is to control the way the tone or colour of a subject appears on the film. With black and white, *tone* is important. With colour film, either negative or transparency, *colour* is crucial.

By fitting a filter to your lens you can effectively alter the contrast or colour balance of your subject to get the best results. (Filters are dealt with in greater detail in sections 26 and 27, pages 56–59.)

FILTERS FOR BLACK AND WHITE
Without a filter (top) the film sees blue sky and white clouds as equally light. Fit a yellow filter, and the tones become contrasted (above).

HAZE FILTERS
The effect of atmospheric haze in a landscape is to reduce the intensity of colour (top). Fitting a 'UV-Haze' filter (above) helps cure the problem.

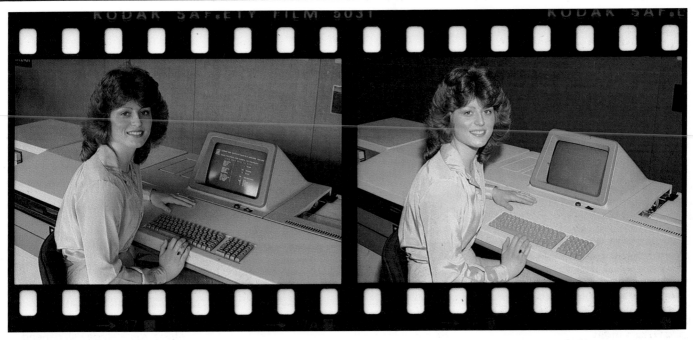

ACCESSORIES FOR LOW LIGHT

Accessories become necessary in poor light when: a) the shutter speed you need is slower than 1/30, so you risk camera shake, or b) the aperture you need for depth of field is too small for the available light.

USE A TRIPOD. . .

Mounting the camera on a tripod allows you to use a slow shutter speed without risking unsharpness from camera shake. You can then select the aperture you need, and preserve the natural light, as in the shot above left.

. . .OR A FLASH GUN

Flash light is fast enough to freeze movement and its colour is suitable for use in daylight. But, as the picture above shows, direct flash looks harsh and gives hard shadows. It also restricts the choice of aperture.

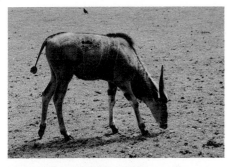

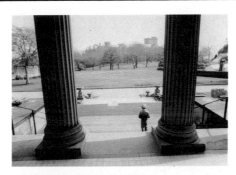

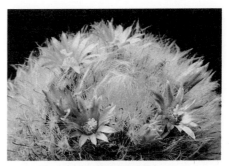

THE LONG FOCUS LENS

When your subject is too far away to be a reasonable size in the frame, and you can't get any nearer, a long focus or telephoto lens is the answer.
This type of lens gives a magnified image compared with a normal lens. A 200mm telephoto, for instance, would give an image four times as large as the standard 50mm when used the same distance away.
Long focus lenses are ideal for sports events where it is difficult to get close to the players; for candid shots when you don't want to go too close with your camera for fear of intruding and spoiling the spontaneity; and for shots of animals (like that above) which may be frightened away.

THE WIDE ANGLE LENS

A wide angle lens has a greater angle of view (ie it takes more in, top and bottom and each side) than the standard 50mm. What a 50mm lens can get into the frame area from, say, 6 metres away, a 24mm wide angle can get in from about 3 metres away.
This makes the wide angle lens useful for working in confined spaces, especially interiors.
Wide angle lenses also have a far greater depth of field than a standard lens. This makes them particularly suitable for shots like the one above which benefit from being in sharp focus throughout the frame area.

CLOSE-UP ACCESSORIES

Normal lenses focus to around 50cm. Many subjects, such as flowers, are still too far away for you to fill the frame with them, even at this distance. Close-up accessories bring closer the near limit for focusing, and enable the subject to be recorded life-size.
There are two main accessories:
close-up lenses, which act like magnifying glasses fixed in front of the camera lens; and
extension tubes, which fit between the lens and the camera, and so extend the outward focusing movement of the lens. Both are easily and quickly fitted and portable. In good light they are ideal for pictures of flowers (above) and insects.

Almost all SLR cameras have removable lenses. That is, the lens can be separated from the body of the camera. This means that you can change from one lens to another without having to change cameras or film. (When you take the lens off the camera the light-tight blinds on the shutter prevent light from reaching the film.)

But, why should you want to change lenses? *The standard* lens on most 35mm SLRs is the 50mm. It is sometimes called the 'human vision' lens, because the area of a subject that it records on film (ie, its 'field of view') is roughly the same as the amount of a scene taken in by the human eye.

This is fine if you simply want to record what you see. But there may be times when you wish you could record part of the picture in greater detail without having to approach nearer to the subject. This is when a change to a lens of longer focus is particularly useful. You can alter the scale without changing your position.

A long focus, or telephoto, lens gives a bigger image on film than the 50mm. With the subject at a set distance from the camera a 100mm lens, for example, will give an image twice the size of that given by a 50mm. Its field of view, however, is correspondingly more limited.

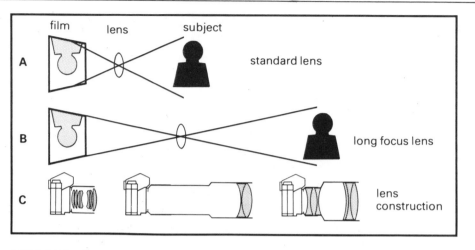

THE LONG FOCUS LENS
A basic long focus lens simply extends the distance between the glass elements of the lens and the film plane. It is this which gives the magnified image. Diagrams A and B in the illustration above show that by increasing this distance (known as the 'focal length') a long focus lens will produce an image of a distant subject the same size as that produced by a shorter focus lens much closer to the subject. This means that with a long focus lens you can get greater detail.

TELEPHOTO DESIGN
There is obviously a limit to the physical length of a lens. So, to reduce the bulk of long focus lenses, the 'telephoto' construction is used. Extra optical elements take the place of the extra length. This is shown simply in diagram C above. On the left is a standard lens, in the centre a long focus lens, and on the right a telephoto of the same focal length. Some telephoto lenses are less than half the length they would be if they were of simple long focus construction.

THE 85mm 'PORTRAIT' LENS
The 85mm telephoto gives an image 1.7X larger than the standard 50mm. It is often called a 'portrait' lens because it is ideal for this kind of picture. Similar lengths include lenses like the 80mm Praktica and many 90mm close-focus lenses. Most lenses of this focal length are compact. Some are as fast (that is, have a wide maximum aperture) as 50mm lenses—with a maximum aperture of f2 or even f1·4. Optical quality is usually excellent. The 85mm is also a fine selective lens for general shots, like that of the train above.

THE POPULAR 135mm
135mm may seem an odd focal length to be popular, compared with the 50mm, but it gives 2.7X magnification while still being easy to use. Fairly distant subjects are pulled in (see above), yet you can still take a head-and-shoulders portrait in a normal room.

The maximum aperture of a 135mm lens is usually between f3·5 and f2·5, and it is about twice the length of a 50mm. Because so many are sold, the 135mm is often the cheapest lens in the telephoto range.

THE 200mm 'ACTION' LENS
The 200mm gives 4X magnification compared with the standard 50mm. This is equivalent to blowing up 1/16th of the normal picture area to fill the frame (see above). It is reasonably priced, easy to handle and will usually have a maximum aperture of about f3·5. It is an ideal outdoor sports lens. Most 200mm lenses do not focus much closer than 3 metres and are therefore unsuitable for use indoors. Think hard whether you need such a powerful lens before buying a 200mm as your first or only telephoto.

TELEPHOTO CONVERTERS

One of the cheapest ways of adding a telephoto to your outfit is to buy a tele-converter. A converter is far cheaper than a separate telephoto lens but performs much the same job. It fits between the SLR body and another lens. Normally the first lens you use with a converter will be a 50mm. If you buy other lenses later, it will work with these as well. The tele-converter effectively extends the focal length of a lens. A 2X converter doubles the focal length (50mm becomes 100mm). A 3X converter trebles it (50mm becomes 150mm).

CONVERTERS AND EXPOSURE

When using a tele-converter exposure must be increased. This is because although the amount of light from the subject remains the same whatever lens is used, with a converter fitted it has to cover a greater area of film. A 2X converter magnifies the image to twice the *size,* but 4 times the *area,* so it must receive 4 times as much light (an exposure increase of 2 stops). The picture above was taken with a 50mm lens. For the right-hand picture a 2X converter was added. Exposure was increased by 2 stops. The diagram right shows the positioning of the converter.

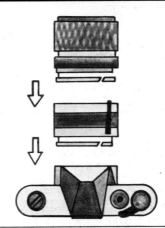

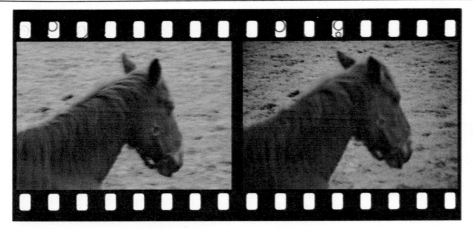

DISADVANTAGES OF TELEPHOTOS

Telephoto lenses need much more careful focusing than standard lenses. You see this as soon as you look through the viewfinder. They are harder to hold steadily and camera shake (above) shows up strongly. In fact, any faults which might occur with a 50mm but which may not be very noticeable, are magnified by a telephoto along with the size of the subject. Maximum aperture is not a problem with today's fast films, but don't hesitate to use a wide enough f stop to avoid slow shutter speeds.

ADVANTAGES

Telephotos are selective and help to eliminate unwanted surroundings, even if you cannot approach the subject closely. You can take pictures without being noticed, so they are good for candid shots. Their shallow depth of field can throw unwanted backgrounds out of focus, but take care to avoid shots like that above. The more distant viewpoint used with a telephoto is more flattering to faces than close-up views. Noses especially, appear in better proportion .

FLATTER YOUR FRIENDS

This portrait was taken with a 100mm telephoto. Distracting background detail has been cut out because of the limited field of view and the slightly flattened perspective is flattering.

Lightweight, relatively inexpensive medium telephoto lenses and zooms are probably the first choice for long lenses. At focal lengths from 85mm to 200mm, they perform and handle quite like the 50mm standard lens. Over 200mm, telephoto lenses produce dramatic pictures—but they also require more care with technique. Experiment with teleconverters or binoculars.

Converters for use with any lens will turn medium telephotos into long ones quite simply. Convert a 200mm lens into 400mm with a ×2 converter or 600mm with a ×3 converter. With a variable converter kit you can get focal lengths in between as well.

Binoculars: can allow you to take telephoto pictures with only a standard lens and a suitable adaptor. Use one barrel only, with the eyepiece about ½ inch (1cm) in front of the front element of the camera lens. The resulting focal length will be the length of the lens multiplied by the binoculars' power—50mm used with ×8 binoculars gives 400mm. Keep the camera lens wide open. The effective aperture is that of the magnification × focal length of camera lens divided by the binocular aperture. So 8 × 50 binoculars with a 50mm lens work at about f8.

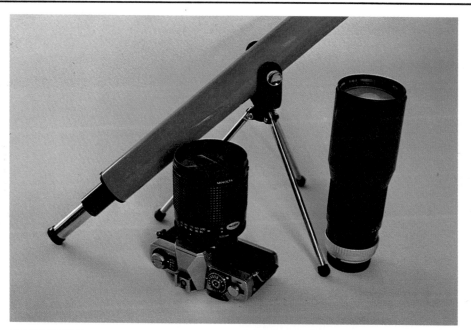

TELESCOPES
Unlike binoculars, telescopes have detachable eyepieces. This means that they can be fitted directly to an SLR camera body using an adaptor. The greatest magnification comes from astronomical telescopes, but these give low effective apertures.

MIRROR LENSES
Alongside the telescope and the conventional 400mm telephoto lens, the picture above shows a barrel-like lens which is also a long telephoto. This is called a mirror lens and is far more compact than a normal telephoto with focal lengths from 250-1000mm.

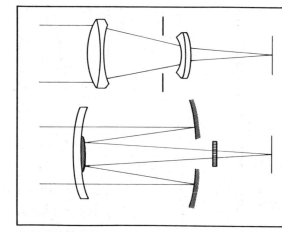

◄ The telephoto lens has a special construction which allows it to be made much shorter than its actual focal length. This requires extra lens elements at the rear of the lens.

◄ The mirror lenses uses mirrors to 'fold' the light on its path through the lens barrel, as shown here. This requires a fat lens, but it can be made much shorter than a telephoto.

MIRROR LENSES VERSUS...
The choice between a mirror lens or a telephoto lens of the same focal length has various pros and cons. Mirror lenses are far lighter and easier to handle but they are about twice the price of orthodox telephotos. And cheap mirror lenses are less sharp than cheap normal telephotos. They are more vulnerable to rough handling and can be costly to repair. The fat barrels can be slow to focus. They have a fixed f stop and require filters (fitted on the rear) to cut down light.

NORMAL TELEPHOTOS
Bulk and camera shake are the chief problems of the normal telephoto lenses. If you need to use a long telephoto quite regularly, this can be an important consideration. The advantages are that they are less delicate and that the weight can make them easier to hold steady. They have variable apertures—a 400mm f6·3 lens stops down to f22 or even f32—and they are faster to focus. You can also buy two telephotos of quality for the price of one mirror lens.

DOUGHNUT EFFECTS
The design of the mirror lens makes doughnut shaped rings appear in out-of-focus highlights (as above). This only shows up in sparkling highlights, and can be used as a creative effect.

SUPPORTING A LONG LENS

A 500mm lens covers an angle of only 5°. A photographer with a shaky hand may easily hold a lens so unsteadily that it moves more than 5° when the shutter is released, and the picture will show severe camera shake. Hold long lenses very firmly and securely and use the highest possible shutter speed to cut down the shake. A pistol grip or shoulder stock (shown above) makes aiming more reliable. If the subject is still, use a tripod. Choose a fast film to maximize the telephoto's shallow depth of field with small apertures. If you have no other support, lean on a wall or car for steadiness.

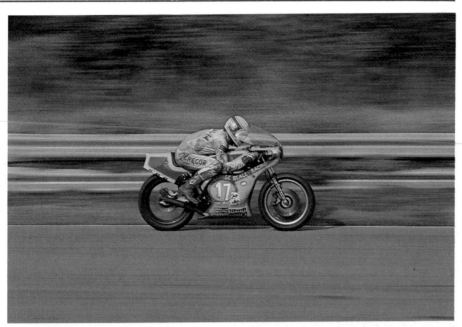

FOLLOWING ACTION

Panning the camera round with a moving target allows you to use slower shutter speeds, giving a blurred background as above. Press the camera back against your forehead, supporting the lens with one hand. Follow through your pan after releasing the shutter.

SHARPNESS AND DEPTH

At wider apertures, only a little of the subject depth will be in sharp focus. Focus on the most important part of the subject, remembering that one-third of the depth of field is in front of the point of focus and two-thirds is behind it.

LONG TELE DATA

Recommended shutter speeds

300mm	1/250 minimum
400mm	1/500 minimum
500mm	1/500 minimum
600mm	1/500 minimum
800mm	1/1000 minimum
1000mm	1/1000 minimum
1250mm	1/1000 minimum
1600mm	1/2000 minimum
2000mm	1/2000 minimum

Angles of view

300mm	8°
400mm	6°
500mm	5°
1000mm	2.5°
2000mm	1.25°

Size of image of sun or moon

300mm	3mm approx
500mm	5mm approx
1000mm	1cm approx
2000mm	2cm approx

PHOTOGRAPHING SUNSETS

The effects of a telephoto lens are at their most dramatic when you are taking sunset pictures. To get the sun's disc as large as in the picture above you need a 500mm lens. To fill the frame with either the sun of the moon you will need 300mm.

SHOOTING FOR THE MOON

The full moon is a very appealing subject to owners of very long telephoto lenses. With 100 ASA film, give an exposure of 1/125 at f8. Do not use long exposures since the moon is imperceptibly moving and will, therefore, show blur.

Just as lenses of a longer focal length select part of a view and enlarge it to fill the 35mm frame, lenses with a shorter focal length reduce the scale of image detail and take in a wider view. They are called wide angle lenses.

To take an example, a 24mm wide angle gives an image half the size of that of a 50mm. But the area of the subject it takes in is four times as great.

It is this increased angle of view (hence wide angle) which is the greatest advantage of a wide-angle lens. If you are working in a confined space, say a room, it enables you to take in much more of a subject than you could with a 50mm.

Another characteristic of a wide-angle lens is that it has greater depth of field. Even at fairly wide apertures the subject can be sharp throughout the picture area. This means that you can focus on an object quite close to the camera and still be sure that the view beyond will be in focus.

These advantages have led to medium wide angles (usually 35 or 40mm) being adopted as standard for many compact 35mm non-SLR cameras, though another factor is the compactness of the semi wide-angle lens, which permits a flatter, slimmer, camera that often can be slipped into the pocket.

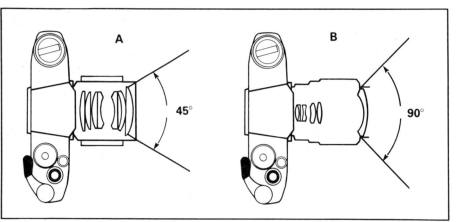

50mm 35mm 28mm 24mm

ANGLE OF VIEW
Diagrams A and B above show the approximate angle of view of a 50mm lens (A) and a 24mm (B). Because the 24mm is half the focal length of the 50mm, it has twice the angle of view.

POPULAR FOCAL LENGTHS
The most popular wide angles are shown in the diagram above. Compared with a 50mm a 35mm is often smaller, a 28mm about the same size, and a 24mm usually larger.

THE 35mm: 'SHORT STANDARD'
Although the 35mm lens is a wide angle, it is no harder to use than a 50mm lens, and can often replace it. The 35mm is an ideal all-rounder. Even cheap versions should be compact and light and optically good. The extra 40% included in the picture means you can photograph small groups indoors, take full-length portraits without standing too far back, and include buildings from reasonable distances. Most flash guns cover the 35mm's view.

THE 28mm: AN IDEAL COMPROMISE
The 28mm lens is a good first choice of wide angle to add to your SLR and 50mm lens. Pictures have a definite 'wide' appearance. The 28mm allows full-length shots in small rooms, sweeping landscapes with lots of sky, and interesting effects if you move in close. It is not ideal for portraits as it produces an unflattering perspective. Be careful, too, with flash. Many flash guns need a special attachment to spread their light over the wide area taken in by the 28mm lens.

THE 24mm: AN ULTRA-WIDE
For dramatic wide angle effects often seen in professional photographs, the 24mm is ideal. It is a favourite lens for the architectural, landscape, news and creative scenic photographer. It is not suitable for everyday pictures as it needs a great deal of care in use. It will distort faces if you get too close. This kind of wide angle may seem to stretch objects near the corners of the picture into elongated shapes. Also, flash can be a problem and special guns or attachments are needed.

WIDE ANGLE CONVERTERS
A wide angle converter is a cheap and simple way to take a wider view with your existing SLR and 50mm lens. It screws in the front filter thread of the 50mm just like a lens hood or filter. Wide angle converters normally have adaptor rings so that if you change your SLR, the converter can fit the new standard lens. The cost is about half that of a cheap separate wide angle. A typical converter (shown above) will turn a 50mm into a wide angle equivalent of a 35mm. Fitted to a 28mm the result is a 20mm ultra-wide view. The f stops marked on the lens still apply, but the focusing scale will be wrong, so you have to focus through the viewfinder. Fitting a converter lets you focus much closer.

TYPES OF CONVERTER
There are two types of converter. One gives a sharp image with straight lines like a normal wide angle, but corners may be slightly blurred. The other, called a semi-fisheye converter, turns straight lines into curves. This may be 'creative' but looks bad in many shots. Both types can be fitted to other lenses as well as the 50mm. The picture above shows a scene taken with a 50mm lens. The shot above right was taken from the same spot but a 2X straight line converter was added. The diagram, right, shows the positioning.

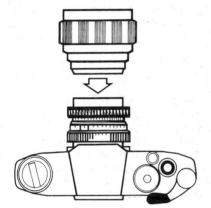

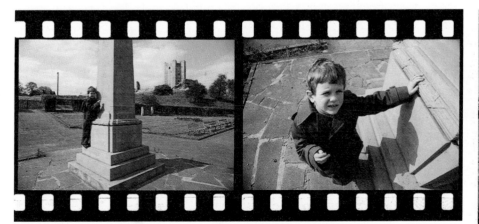

DISADVANTAGES
Using a wide angle calls for care. Look at the two shots above. They are typical of bad wide angle pictures. To get a reasonably-sized image on the film you need to be closer with a wide angle. Many people stand too far away and include too much irrelevant background. Compose your shots deliberately. The shot above right shows what happens if you move closer but don't think. Children have to be photographed from their own level. Aim down and you get this ugly effect.

ADVANTAGES
The big advantage of any wide angle is that you can include subjects without missing parts off, even in tight situations. Because they take in more of the scene, there is less chance of missing a shot entirely. The subject may be lost in the frame, but it is always possible to crop or enlarge it later. Wide angles also need less critical focusing (you see this when you look through the viewfinder), and more of the depth of the picture is sharp at any given aperture.

WORKING WITH WIDES
The good qualities of a wide angle come out in this picture. The lines of the subject, the sky, the viewpoint and strong perspective all work together.

One big drawback of interchangeable lenses is that they have to be changed. To get a different field of view—to change from a distant shot to a close up, for example—you have to remove one lens and fit another. If the subject moves or the light changes while you do this, the picture is lost.

Another drawback is the jump between one focal length and the next. You may own a 50mm standard lens and a 135mm telephoto. But a particular shot could need an 85mm lens for the best composition. In some cases you can change your position and move closer to, or farther from, the subject. However this is not always possible. In sports photography, for instance, the shooting position is often fixed by the seating arrangements. The subject action may also be in a fixed place.

To overcome these problems, the zoom, or variable focal length lens, can take the place of three separate lenses (in many cases) *and* fill the gaps between.

In addition to focus and f stop controls there is a third setting—focal length. This can be changed to provide exactly the required focal length between the marked minimum and maximum. Much time is saved by not having constantly to change lenses.

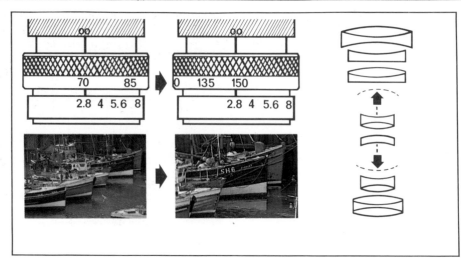

ZOOM RANGES

The longest and shortest focal lengths are always marked on a zoom and these are used to describe the lens. Often they are unusual: you can buy a 43-86mm zoom, for example, but not separate 43 or 86mm lenses.

The 'ratio' of a zoom is the difference in the magnification from the shortest to longest setting. A 70-210mm is a 3 to 1 zoom: at 210mm the image is three times as large as at 70mm.

ZOOM OPERATION

The diagrams above show the controls of a 'twin-ring' zoom, set on 70mm (left) and 150mm (centre). Note the change in magnification of the image. This type of zoom has a separate zooming ring. Another type is the 'one-touch' zoom, which combines the zoom control *and* focusing ring. The right-hand diagram shows how the middle elements of the lens move as the zoom control is operated.

WIDE ANGLE ZOOMS

Wide angle zoom lenses are fairly popular, although they are difficult to make, comparatively expensive, and can be very large and heavy. Nearly all wide angle zooms go up to around 50mm maximum focal length, so they can be used in place of the standard lens. They do not usually have close focusing. There is some loss of quality compared with standard and fixed-focus wide-angle lenses. There are several 28–50mm zooms which are the same size as a normal 50mm lens, but limited to f3·5 or f4·5 maximum aperture.

Sometimes the maximum f stop changes from one end of the range to the other. Wide-angle zooms are useful if you do a lot of landscape or architectural (both inside and out) photography. The shot above left was taken with a 28–50mm wide-angle zoom.

MID-RANGE ZOOMS

Some cameras are sold with a zoom lens as an alternative to the standard 50mm lens. 'Standard' or 'mid-range' zooms are ideal if you want only one lens. A typical range would be 35-70mm—from wide angle to portrait. The disadvantages, compared with a normal 50mm lens, are loss of quality, higher cost, extra size and weight, and limited aperture (some are f2·8 but most are f3·5). Many have close-up controls. If you decide to change to a mid-range zoom in place of your standard lens, check carefully that the normal focusing range is good enough. Sometimes the focusing stops at 1·5 or even 2 metres unless you use the close-up control. Mid-range zooms are ideal for family photographs and general snapshots. The shots above (centre and right) were taken at either limit of a 45-90mm zoom.

TELE ZOOMS

Telephoto zooms (used for the shot above) are popular because they get rid of the need to carry more than one bulky long lens. A 70-210 zoom is usually about the same size as a 300mm telephoto. An 80-200mm zoom, with a slightly smaller range, will be the same size as a 200mm. Most tele zooms cover up to 200mm and have a ratio of 2.5:1 to 3.5:1. Typical ranges include the two above, 75-206mm, 100-300mm, and 90-230mm. The size of the lens depends mainly on the range and maximum aperture.

PORTRAIT ZOOMS

If you do not want such a large range of focal lengths or such a powerful tele magnification, a portrait zoom is much smaller. Nearly all of these have a range of either 70 or 75mm to 150mm. A few run from 50mm to 135mm. Many people buy them instead of a 135mm lens because they are more versatile and only slightly bigger. Set on the maximum limit, shots like that above are perfectly possible. If more power is needed, most makes let you fit a tele converter. This gives you a 140-300mm zoom from a 70-150mm.

CLOSE FOCUSING

Many zoom lenses have a close focusing or 'macro' facility, which lets you take close-up shots (see picture above) without extension tubes or extra lenses. In some zooms the focus control is extended so you get continuous focusing down to under a metre. On other lenses, a button or twisting ring control alters the zoom action to a focusing action, so instead of zooming, the lens focuses very close. Another type has a close-up range as a continuation of the zoom ring action.

CREATIVE ZOOM EFFECTS

Zooms open a world of creative chances which you don't have with ordinary lenses. With a zoom you can adjust the composition precisely—no compromise is needed. By changing viewpoint and focal length you can get exactly the shot you want. Dramatic creative effects are also possible. One of the most popular of these is to zoom during a long exposure. You turn the zoom from short focal length to long rather than vice-versa. This gives a streaked image which seems to rush out of the picture towards the edges.

EXPOSURE

In the shot above, the normal scene (left) was converted to the zoom effect using a mid-range zoom. By stopping down to f22 and using slow film, an exposure of 1/4 second was possible in daylight. The zoom control was moved from 40mm to 80mm.

WHEN TO START ZOOMING

If you try this effect, support the camera firmly. Use a tripod. The best results are obtained if you start the zoom just after the shutter opens, so that part of the subject stays sharp. Experiment with moving subjects too. Results look best in colour.

One of the great advantages of the camera is that it can take an area of detail and isolate it from an overall scene. A photograph of this detail can then be studied at leisure, without the distraction of the original surroundings. This is especially useful when dealing with small subjects which may be difficult to see in detail at first glance.

However, if you want a small subject to fill the frame you run into problems with your standard 50mm lens. The focusing range of most 50mm lenses extends from infinity to about half a metre. This means that only those parts of a subject which are more than half a metre from the camera can be recorded in focus. This makes sharp close-ups of flowers or birds for example, almost impossible.

The solution is to use special close-up equipment, and this is particularly suited to SLR cameras. You can see through the lens *and* through any close-up attachments, so focusing and careful framing are easily achieved simply by sighting through the viewfinder. All SLRs can be used with close-up attachments and most of the equipment is simple and reasonably cheap.

The SLR camera is particularly suitable and useful for close-up work and is often chosen especially for such purposes.

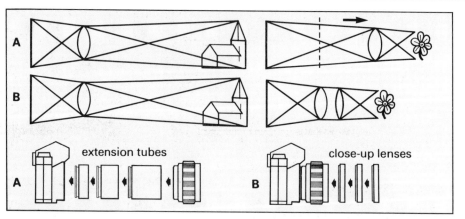

extension tubes close-up lenses

MOVING THE LENS

Look at the focusing action of any SLR lens. As you move the focusing ring to closer distances, the front of the lens moves outwards. The further the lens moves away from the film the closer you can focus. Every lens has its focusing limit, but you can extend this on an SLR by using 'extension tubes'. These are rings which when placed between the lens and the camera body 'extend' the distance between the lens and the film. They are sold in sets of three and can be used singly or in combination for much closer focusing (up to 4 cm from the subject).

ADDING MORE LENSES

The diagrams above show the two main ways of getting a close up. You can either (A) take the lens closer to the subject; or (B) you can magnify the image. With your standard 50mm lens you can magnify the image by attaching close-up lenses. These screw into the front of the lens and work like a magnifying glass. They are marked in 'dioptre' strengths. One dioptre focuses at 100cm away, two dioptres at half that distance (50cm), three dioptres at one third (33.3cm) and so on. As with extension tubes they can be used singly or in combination.

USING EXTENSION TUBES

Extension tubes are harder to use than close-up lenses but allow closer, sharper pictures. Because the lens is moved closer to the subject, less light reaches the film. The finder image is also dimmer. A TTL exposure meter adjusts for this, but compensation is needed if you use a manual camera or flash. Extension tubes are bulky and can be expensive. They are sold in sets of three. You must remove and refit the camera lens to use them (see above). The focusing distance depends on the focal length of the lens used. A 12mm extension tube has very little effect on a telephoto lens, a moderate effect on a 50mm, and a strong effect on a wide angle.

CAMERA COUPLINGS

Unlike the close-up lens, extension tubes break the link between the lens and the camera. Some makes, called 'auto tubes' have couplings to overcome this. Make sure that the tubes you buy match your SLR.

FOCUSING WITH TUBES

In close ups with tubes, moving the focusing ring of the lens has little effect on focusing because the depth of field is very limited. Focus by moving the camera backwards and forwards. The picture above was taken with tubes.

USING CLOSE-UP LENSES

Close-up lenses (CUs) are easy to use. They screw in like filters and have no effect on exposure. The focus distance is determined by the power of the close-up lens, not by the lens you fit it on. A 3 dioptre (+3) close-up lens will set the focusing distance at 33.3cm, whether you use it on a 200mm lens or a 50mm. The focusing image in the SLR finder is bright when close-up lenses are used. They are pocketable, and can be bought singly. You do not need to remove the camera lens to fit one. These are good reasons for choosing them for your first close-ups. In theory they take the edge off picture sharpness, but this can be ignored for most photographs (see above).

POWERS OF LENSES

Popular CU lens strengths are +1, +2 and +3 dioptres. The first has little effect. A +2 gives distances of 50cm and closer. It is ideal for extending the range of many lenses which have a close focus limit of 50cm, giving an unbroken range. A +3 gives distances 33.3cm and closer, but if your lens does not focus this close already, a +3 will leave a gap. The full set of three CUs lets you focus on any distance down to about 12cm with most cameras. (You measure the distance from the front of the lens, not from the film). The shot above is a typical +2 dioptre close-up.

USING TWO TOGETHER

Two or three CU lenses can be used together for closer distances. The picture above was taken with a 50mm lens. The distance scale on the lens was set to its closest focus of 50cm. Two close-up lenses, +3 and +1 (total +4), were then added, giving a focusing distance of 25cm from the front of the lens. On a 35mm negative this would give an image about 1/5 life size.

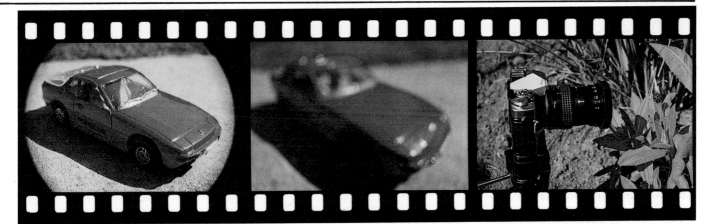

CLOSE-UP LENS PROBLEMS

1) Normal close-up lenses are so limited in magnifying power that several may be needed together for very small subjects. Use too many and you get cut-off corners on the picture, as above. This never happens with tubes.
2) Picture quality suffers at the edges with close-up lenses, so important details are best kept central. Small apertures are needed. Using two or three together can increase flare.
3) If you have lenses with different filter threads you may need two sets of close-up lenses.

EXTENSION TUBE PROBLEMS

1) Extension tubes made for use with the standard 50mm lens may not be very convenient with others. For example, you may want to focus closer with a wide angle but find you get the blurred result above. With this lens (17mm) the toy car would need to touch the front glass to be sharp.
2) Some wide aperture 50mm lenses (f1·4 or f1·2) give pictures badly blurred at the edges when used with tubes.
3) Tubes are not very flexible. With some lenses, none of the three tubes in a set will give the distance you want.

ZOOM CLOSE-UPS

For about the same price as a set of cheaper extension tubes you can buy a special zoom close-up lens. Using two glass elements, a variable close-up lens like that above has a range of +1 to +10 dioptres (100cm to 10cm focus), with no gaps. It seems a good answer to problems, but the picture quality is usually poor. The edges are blurred, and at +10 power, cut-off occurs. All close-up shots are better if you use a small aperture like f16, but with variable close-up lenses this is vital.

Ultra close-up photography: 18

Normal close-up lenses and extension tubes are easy to use to take good pictures of fairly small, close-up subjects. But when you want to get really detailed shots of very small subjects—to appear life-size or larger on the film—you may need more. Macro equipment is harder to use than ordinary close-up equipment, but it is more versatile.

There are several ways of getting life-size images on film, using any normal SLR. Macro photographs need very good light: there is no point in trying to take hand-held ultra close-ups on very dull days or with very slow film. You will require small apertures to keep the subject sharp so, in addition to the equipment shown here, you will also need a steady tripod.

Magnification of the subject in a photograph should be related to the negative or slide size, not the size of the print or the projected image. Life-size images are described as 1:1, half life-size 1:2, twice life-size 2:1 and so on. These are called *reproduction ratios* and can be important in the exposure calculations you need to make.

The higher the magnification the greater depth of field is required and extra exposure is needed, as this section describes.

REVERSING THE LENS

The *cheapest* way to take sharp macro photographs is to fix your lens on to the camera back to front. This only works with standard or wide angle lenses. A special adaptor ring, known as a reversing ring (shown above), screws or bayonets into the lens throat. The lens is screwed on to this using the front filter thread. The lens is now further from the film and focuses extremely close-up. The reversed optical arrangement helps to keep the picture sharp from corner to corner. To set a small aperture for sufficient depth of field, you will have to close the aperture manually: your camera instruction book should show you how.

MACRO LENSES

Lenses which focus very close without the help of extension tubes or bellows are called *macro lenses.* They can also be used for distant shots and focus to infinity. Another difference is that they are corrected for close-ups so results are much sharper at the edges of the frame than with ordinary lenses and close-up accessories. Most macro lenses are about 50mm, but limited to f2·8 or even f3·5 maximum aperture. They will normally focus to half life-size (1:2) or life-size (1:1). You can also buy 90 or 100mm macro lenses which can be a more sensible buy as they do not duplicate your existing 50mm lens but give you something different.

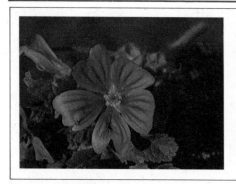

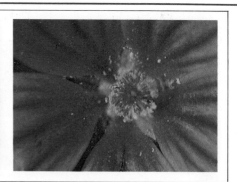

REPRODUCTION RATIOS

Most macro lenses and some bellows are engraved with reproduction ratios. With bellows, these take account of what lens you are using. For example, one scale is marked for use with a 50mm lens and one for a 100mm lens. The picture above was taken with a 50mm lens and bellows extended to 25mm. This gave a reproduction ratio of 1:2 or half life-size. With 400 ASA film, the exposure required was 1/500 at f8. Macro lenses will often only focus to half life-size and less—1:3. 1:4, 1:5 and so on. These are suitable reproduction ratios for pictures of prints, postcards and flowers. Shots like this can be hand-held.

EXPOSURE

This life-size (1:1 ratio) picture was taken with the same 50mm lens and 50mm of extension. This extra extension makes the image dimmer because the lens is further from the film. The lens was left on f8 for this shot, but because one extra stop of light was lost in the extra bellows extension the exposure time had to be increased to 1/250. Through-the-lens metering will cope with this automatically, as will an automatic exposure camera. Set the smallest aperture you can for good depth of field unless your subject is perfectly flat. Since the central focusing ring will go dark, use the plain parts for focusing.

DEPTH OF FIELD SHUTTER SPEEDS

The more you magnify the image, the less depth of field is available to you. In this twice life-size picture (2:1 ratio) only a couple of millimeters from front to back is sharp. With the 100mm of bellows extension needed, exposure for this shot was 1/60 at f8. To get more depth of field, you would need to set a smaller aperture and to use a correspondingly slower shutter speed. The problem with slow shutter speeds in close up photography is that even with a tripod the smallest amount of camera shake or subject movement will be recorded. For these reasons, close up photography at high magnifications normally needs flash.

MACRO BELLOWS

For bigger-than-life-size magnification you can buy bellows that fit between the camera and the lens. They act like extension tubes but better. You can extend them to any point in their range, rather than having to progress in steps. Simple bellows are cheap but do not have couplings to stop down the lens automatically. The best bellows retain full metering functions with many extra features. Use them with a reversed standard lens, a macro lens or—for high magnification—a reversed macro.

FOCUSING RAILS

At very close distances it is easier to focus by moving the camera backwards or forwards than with the focusing ring, (If you are using a reversed lens, you will not be able to use the focusing ring at all.) Focusing the lens alters the magnification, which can be very critical with macro pictures. Focusing rails (shown above) fit between the camera and the tripod: turning the knob moves the whole assembly (camera and bellows) for fine positioning.

FOCUSING STANDS

Macro stands hold the camera vertically like a microscope for easy table-top use. The subject is held on a flat 'specimen' stage—ideal for photographing stamps or coins.

CALCULATING EXPOSURE INCREASES AT MACRO MAGNIFICATIONS

As the lens is moved further from the film by extension, the image becomes dimmer. This table gives approximate exposure compensations with a 50mm lens.

Extension	Reproduction ratio	Increase in exposure
20mm	1:2	1 stop
50mm	1:1	2 stops
100mm	3:2	3 stops
150mm	2:1	4 stops
200mm	3:1	5 stops

To calculate the true aperture at any extension—when you are using a hand held light meter, or when you are working with flash—use this formula. Add the focal length of the lens to the extension of the bellows (from the front of the camera to the back of the lens). Divide this by the lens focal length. Then multiply the aperture that is set on the lens by the result, ie:

$$\text{True f stop} = \frac{\text{focal length} + \text{extension}}{\text{focal length}} \times \text{f stop}$$

(Auto tip: automatic SLR metering works all this out, but you should cover the eyepiece to exclude any stray light.)

MANUAL FLASH

With automatic flash guns, the sensor is unreliable at distances as close as the one needed for the shot of these crystals. Use manual flash, working out the exposure by trial and error. Start at the closest distance on the scale and work down, bracketing your exposures.

POSITIONING FLASH

Since you lose light with extension attachments, gain light by positioning the flash gun nearer the subject. If you fix the gun to the lens itself, the flash gun is automatically brought closer to the subject as the extension becomes progressively longer.

Completing your outfit:19

With your SLR camera, lenses, filters (see section 26, pages 56–57) and close-up accessories you have an outfit—a system. All the items combine to make a working kit to tackle many different subjects and conditions.

At this stage, the system is compact enough to carry around with you in its entirety, but you will need something in which to carry it. If not, you might occasionally be tempted to leave one or two items behind—a close-up lens is rarely needed when shooting motor racing, for example; a telephoto is probably of no use on a trip round the interior of a stately building. But, it still pays to carry your outfit with you. There is nothing more frustrating than knowing you have the right equipment for a once-in-a-lifetime picture, but have left it at home!

The solution is to complete your outfit with a good case or holdall. This can also hold some important minor accessories and supplies of film.

There are many types of camera case sold, from expensive aluminium to soft vinyl. Show your outfit to a dealer and he will usually have one to fit it. There may even be one made to match your camera. One idea is to cut a foam rubber case insert to take the actual items of equipment which you own.

CARRYING AND PROTECTING
The case above protects valuable equipment, as well as making it easy to carry. Proper camera outfit cases have soft linings and foam padding. Check that equipment fits snugly, is fairly evenly distributed and does not jostle.

WHAT SIZE OF CASE?
Don't buy the smallest case to fit your kit. Allow room in the case for the extra lens you may soon need. Bags with moveable dividers are versatile; ones with foam liners cut into shapes need new liners if the kit is changed later.

WHAT CAUSES FLARE?
Often bright light from outside the picture area enters the camera lens. Instead of being focused on the film it hits parts of the lens interior and bounces around inside. The glass surfaces and the metal aperture blades also reflect light. This can have two effects. If the light source is large, like a bright sky, the reflected stray light puts a soft foggy veil over the whole picture (see above). If it is small, like a bright sun, spots of light (often hexagon-shaped because of the aperture) are scattered around.

LENS HOODS PREVENT FLARE
Compare the shot above with that on the left. For this shot a lens hood was fitted before taking the picture. The hood fits in front of the lens like an eyeshade. It shields the lens from bright light coming from outside the picture area, but stops short of actually appearing in the frame itself. The best lens hoods are rectangular, to match the picture shape, but most are circular and therefore cheaper. Make sure the hood suits the lens. Too long and narrow and it will cut off the corners; too short or wide and it won't work.

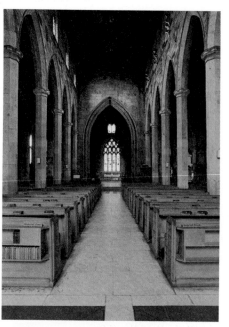

TRIPOD AND CABLE RELEASE
No outfit is really complete without a tripod. It is especially useful for subjects in low light like that above, where the subject is too large for flash to be effective. If you have a tripod a cable release is essential.

SHAKE-FREE ACCESSORIES

Your tripod (1) probably straps outside your case, but inside, carry a cable release (2). This connects to the camera and replaces the shutter button for tripod exposures. It is flexible and prevents camera shake when firing.

CLEANING THE KIT

Lenses collect dust, so carry a blower brush (3) to blow it off. Cleaning cloths (4) polish lenses but must be kept in dust-free bags. It is better to leave a filter on each lens and to clean that. Dust the camera top as well.

HOODS AND FLASH CABLE

Lens hoods (5) protect lenses and cut out stray light which causes flare (see below). Each lens should have one. A long flash extension cable (6) lets you create dramatic lighting effects or cure red-eye problems easily.

FORMAL PORTRAITS

However bright the lights in a studio you are almost certain to need an exposure of 1/30 or slower, so a tripod is needed for formal portraits like that above. The cable release prevents movement when the shutter is fired.

CREATIVE OFF-CAMERA FLASH

With a long extension cable for your flash, lots of interesting lighting effects are possible. You need to experiment for the best results. Buy a cable which is well over 2 metres long, so you can move the flash well away from the camera. A long, uncoiled cable is cheapest and most versatile. You can also buy flash mounting shoes for fixing the flash to a tripod so that you don't have to hand-hold it.
Always work out your exposures on flash-to-subject distance, not camera-to-subject, or use auto flash.

TRY THESE TECHNIQUES

Direct sidelight (above left): hold the flash a few feet to one side of a person's face, keeping it slightly in front rather than behind. The result is a half-lit face.
Silhouette: stand the subject in front of a white background. Use flash on the background only and you get a pure black silhouette.
Inverted lighting: Ask your subject to hold the flash at waist level and aim it up. Lighting a face in this way produces dramatic portraits like that above.

The word photography comes from the Greek for 'light writing'. Of all the elements which can make or break a picture, lighting is the most important. In a studio a photographer can control light, but outdoors you have to be able to recognise and use existing light.

It isn't just a question of dull days producing duller pictures than sunny ones. Light quality can: alter (a) the brilliance of colour; (b) how the subject is 'modelled' in terms of how three-dimensional it appears; (c) how well it is picked out from the background; and (d) whether or not texture is shown.

Sunshine gives a hard light which casts sharp shadows, makes colours brighter, throws texture into relief and, when used carefully as sidelighting, gives a pronounced 3-D effect and provides modelling to subjects.

Overcast days give soft light with no hard shadows, little ability to emphasize texture, and an overall gentle gradation which makes shapes look smoother.

Direct sun can come from the front, side or back of the subject, and in each case it will produce a totally different effect.

White clouds which do not obscure the sun make the light less hard, because they reflect light into the shadow areas, thereby reducing the overall contrast.

KEEPING THE SUN BEHIND YOU
The picture above shows the kind of simple, reliable 'over-the-shoulder' lighting often used by beginners. The shadows fall behind the subject, the light is evenly bright and detail good, but there is no modelling or texture.

WATCH OUT FOR SHADOWS
The time of day affects picture results, especially in the evening when the light is much lower in the sky and comes from the side or directly behind the camera. It is then that the otherwise 'safe' method of keeping the sun behind you can fall down. The picture above shows what can happen.
The low sun has cast the photographer's own shadow into the picture. In some light this is almost inevitable unless you can aim the camera upwards or let the shadow fall in an already shaded area. Other nearby objects may also cast unwanted shadows in this kind of light.

PORTRAITS AND LIGHT
Lighting is important in portraiture because we like to see the shape, colour and texture of a person's face. However, a harsh, accurate rendering is rarely flattering—it shows up lines and blemishes. So unless you are taking a character study of a weatherbeaten face, deliberate sidelighting is ruled out.
You might expect over-the-shoulder light to work well for portraits, but look at the picture above. The subject's eyes are screwed up due to the glare. Although people usually also smile when they do this, the effect is tense.

REPOSITION THE SUBJECT
On a dull day there are no problems. But in sunshine you get a much better result (above) by moving your subject so that the sun is on her back. To lighten the now shaded face, use a light surface to bounce the light back.

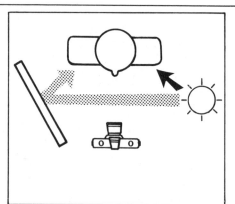

USING FILL-IN
Reflecting light onto the shaded parts of a subject is called 'fill-in'. It works in much the same way as using a mirror to flash signals. You use a reflective surface to bounce the light in the direction you want it (see diagram above). Any reflective surface will have the same effect. A purpose-made silver reflector sheet is ideal, but you can equally well use a newspaper, an open book or a convenient whitewashed wall.
If you are shooting colour film don't use a coloured reflector, as light of this colour will be thrown on to the subject, giving false skin tones.

FRONT LIGHT IS TOO FLAT

One challenge of photography is to make three-dimensional subjects translate to two-dimensional paper. The main clues should be the texture and form of the subject. But direct, over-the-shoulder lighting, falling on the front of the subject is 'flat'. It gives no shadows to throw the subject into relief and so reveal its three-dimensional form.

The picture above was taken with the light behind the camera. There is very little shadow on the bricks; they show hardly any texture and the whole image looks rather flat.

SIDELIGHT FOR TEXTURE

When the sun strikes the surface of a subject at an oblique angle, the effect of cross-lighting (see above) gives an impression of solidity and texture. Clues to the form of the subject are given by the areas of highlight and shadow which form on the surface. To make the most of this effect you should expose for the highlights. That is, take a spot reading from one of the brightest parts of the subject.

Cross, or side, lighting does not only occur in low sunlight. It is often obtained when the sun is high; the effect is then from top to bottom.

OVERCAST LIGHTING

Overcast light often has a greater modelling ability than flat sunlight, because it usually has some directional bias due to thinner cloud in parts of the sky. Even a totally overcast day has a strong overhead bias, so that completely flat results are only produced if the ground acts as a big reflector. Sand and snow can do this. The photograph above was taken under dull conditions, but there is still plenty of three-dimensional quality in the subject matter, and the absence of deep shadow makes it possible to see detail throughout the scene.

SHOOTING IN SILHOUETTE

By taking a photograph with the light coming from directly behind the subject you can obtain a silhouette. You take the exposure reading straight from the overall scene without making any correction for the strong light behind the subject. This will give a correctly exposed background but a subject in deep shadow.

Silhouettes can be a flattering way to take a portrait because they hide facial details, and more importantly, blemishes like lines and wrinkles, in shadow. A silhouette can also be used to emphasize shape, as in the picture above, and is particularly effective if the sun is low enough to give a rim of light round the subject.

COPING WITH BACKLIGHT

When faced with a subject positioned against a large expanse of bright background there are three courses of action open to you. You can set the exposure calculated from an overall reading of the scene. This will give you a silhouette image of the subject, and a correctly exposed background. Or, you can calculate the exposure from a close-up reading of the subject. You will then get a correctly exposed subject but an over-exposed background.

The final choice is to use a reflector to fill in shadows on the subject (above). Again take the reading from close to the subject, but as it is now much brighter the exposure will be much more accurate for the whole picture.

Wide aperture lenses and 400 ASA film extend photography into dim lighting conditions without using flash. Nearly all SLRs have standard lenses with maximum apertures wider than f2·8, and 400 ASA film is available as black and white, colour negative and colour slide film. An SLR with an f1·4 lens loaded with 400 ASA film can take good shots in light one-eighth as bright as an SLR with an f2·8 lens loaded with 100 ASA film.

The exposure metering on modern SLRs will take accurate readings in low light—though using 400 ASA film does not make the camera able to meter in dimmer light: the meter has a fixed limit.

The main advantage of fast film is to allow you to use faster shutter speeds and avoid camera shake. A shot that would need 1/8 sec on 100 ASA film could be hand-held at 1/30 on 400 ASA film.

By special processing, most slide films can be 'pushed' so that they give one or two stops more speed. A 400 ASA film can be pushed to 800 or even 1600 ASA. Colour negative film cannot be 'pushed'. When film is 'pushed', the contrast rises, exposure latitude decreases, the grain becomes coarser and the colour balance changes.

LOW LIGHT LIMITS
SLRs with lenses that have a maximum aperture of f1·8 or f1·4 give a good deal of leeway in low light. You can get an accurate TTL meter reading of as long as 1 second with 100 ASA at maximum aperture.

COLOUR BALANCE
Daylight balanced film gives an orange result in artificial light. Tungsten balanced film (above) gives truer results. The fastest tungsten film is 640 ASA; it can be uprated to 1200 or even higher.

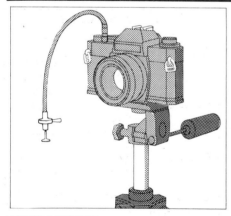

USING A TRIPOD
For perfect sharpness in exposures that are too long to hand hold—1/15 and under—use a tripod and a cable release (above). If the exposure time is longer than a second, however, the film may need more exposure than your meter indicates. A good guide is to add half as much exposure again for times between 1 and 5 seconds, and to double the exposure for times from 5 to 20 seconds. When your shot includes a light source, you can either expose for that, leaving the background dark, or give the shot more exposure to show the rest of the scene.

MOVING LIGHTS
With your camera on a tripod you can record moving lights—car lights or fireworks, for example—as streaks of light. Give long enough exposure for the whole movement to be recorded from start to finish.

EXPOSURE
Be careful not to over-expose coloured lights, fires or fireworks because the colour would be lost. Use a smaller aperture (f8 or f11) for exposures of 1/15 or 1/8 on 400 ASA. Always bracket low light exposures.

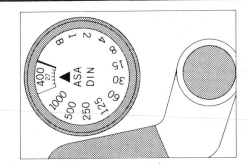

CHOOSING A FAST FILM

All 400 ASA films are more grainy and less sharp than slower ones, but this does not always matter.

Black and white 400 ASA films can be exposed at 650 ASA with many developers and further pushing is possible at the expense of quality.

Colour negative films for prints have good exposure latitude and much colour control can be used when printing. Large prints can show coarse grain.

Colour slide films need more exact exposure than negative ones and colours can sometimes look unnatural with night pictures.

Tungsten balanced slide film is available for pictures in artificial light (not flash). The 160 ASA type has finer grain than the faster kind.

CONCERTS AND THEATRE

Fast film makes fast shutter speeds possible in stage lighting. Meter the lit areas with a hand-held meter or go in close for a TTL meter reading and use it for all shots. More roughly, use half the overall TTL meter reading.

OUTDOOR SHOTS

Fast film also extends your photography into dusk and well-lit night time streets. Base your exposure on the subject alone. If the shot includes bright street lights, allow twice the overall TTL meter reading.

UPRATING FILM

If there is not enough light to use even 400 ASA film and you do not want to use a tripod and a slow shutter speed, you can uprate or 'push process' your film. With 400 ASA film, for example, simply set your ASA dial to 800 ASA (one stop faster) or 1600 ASA (two stops faster) and use the TTL meter in the usual way. When the film is finished send it to the processor marked 'Pushed one/two stops'. (You can only deal with complete films in this way, not individual frames.) The special process may cost from 50-100% more than normal: more laboratories offer this service for slides than for print film. Both types of colour film can also be push-processed at home using one of the kits available.

DISADVANTAGES OF UPRATING

When a film is pushed beyond its officially rated speed its properties alter. There are several disadvantages.

The grain becomes coarser and far more noticeable.

The colours lose saturation and may tend to shift towards red or green.

The sharpness is poor compared to normally rated film.

Black or dark parts of the picture may look grey or slightly coloured, even where there is no discernable shadow detail.

Nevertheless, push processing is a way to get good pictures where it would be impossible to get a picture at all with normally rated film. Use the technique when it is more important to get the shot than to get good quality.

EXPOSURE GUIDE

	160 ASA	400 ASA
Group 1	1/30 sec at f4	1/60 sec at f5·6
Group 2	1/30 sec at f2	1/30 sec at f4
Group 3	2 secs at f8	1/2 sec at f5·6
Group 4	20 secs at f8	5 secs at f8
Group 5	20 mins at f4	20 mins at f8

Group 1: Very bright subjects
neon signs
shop windows with spotlights

Group 2: Bright subjects
fairy lights
festive illuminations
well-lit streets,
shop windows
fairgrounds

Group 3: Average subjects
floodlit buildings (white light)
streets in white (mercury) light

Group 4: Dull subjects
coloured floodlighting
streets in yellow (sodium) light

Group 5: Very dull subjects
moonlit landscapes

A flash gun will almost certainly be among the first accessories you buy for your SLR camera. When there isn't enough light to take photographs at hand-held, action-stopping shutter speeds flash can provide an easy-to-use, portable light source.

There are basically two types of flash: flash bulbs and electronic flash guns. Flash bulbs can only be used once and must then be replaced. Electronic flash, on the other hand will give anything from 50 to several hundred flashes from one set of batteries, depending on its type. It can be connected to the camera either by cable or hot shoe and produces a very short but intense burst of light at the moment the shutter is fully open.

You can use electronic flash whenever the existing light is so dim that you would otherwise have to use very wide apertures—losing depth of field and sharpness—or shutter speeds too slow for hand-held exposures. It is also useful when the subject is unevenly lit or the light, however bright, is coloured. The colour of the light from bulbs and electronic flash guns is matched to colour films to give results similar to sunlight. Remember that the right shutter speed for flash is usually no faster than 1/60 or 1/125 sec.

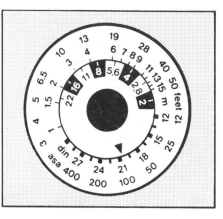

MANUAL FLASH

The most basic type of electronic flash is manual. Once linked to the camera, when the shutter release is pressed it will provide a burst of light of the same intensity and duration every time. You have to work out the exposure needed by reference to the calculator dial (see above). This is usually on the back of the flash gun.

First, you set the ASA speed for the film you are using. Then, corresponding to the distance your subject is from the flash, you read off the required aperture setting. Different distances need different apertures.

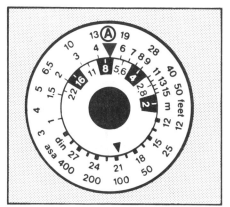

AUTOMATIC FLASH

Automatic flash is far easier to use (though more expensive to buy) than manual, as you do not need to keep changing the aperture setting when you change your shooting distance. Instead, the flash has a sensor which registers its own light being reflected back from the subject. As soon as this reflected light reaches the sensor the output from the flash gun is cut off. On the calculator dial (see above) you simply set the ASA speed and read off the f stop. If the subject is between the closest and furthest distances shown the exposure will be correct.

EXPOSURE ERRORS

The burnt-out, over-exposed picture above is the result of a flash exposure error. This is most likely to happen when you reframe a shot without readjusting the flash. It can be caused by (a) setting the wrong ASA speed on the calculator dial; (b) setting the wrong aperture when using manual flash; or (c) going in too close for the flash range of an automatic gun. Always check these.

FLASH AND DISTANCE

One of the characteristics of a small light source like flash is that the further away you place a subject the less light it receives. You can see from the diagram above that the angle of the light means that it has to cover a greater area the further it travels. In fact, if you *double* the distance between the flash and the subject, the subject will receive only a *quarter* of the light, because the area over which the light is distributed is four times as great. This is known as 'fall off' with distance.

AVOIDING FALL OFF

The picture above shows the effect of fall off. As the people get further from the flash they receive less light and so appear darker in the picture.

If you want to avoid this there are two ways you can do so.

You can choose an angle from where all of the subject is roughly the same distance from the flash. Alternatively, you can reduce the relative distance between the different parts of the subject by moving further away and recomposing the shot.

FLASH SYNCHRONIZATION

Because the burst of light from an electronic flash is so brief (1/1000 of a second or faster) you must be sure that at the moment the flash fires the whole of the frame of film is exposed to its light. With most focal plane shutters the whole frame is only exposed at speeds of 1/60 or slower (see sections 5 and 6 pages 14–17). At faster speeds only part of the frame is exposed at any one moment, so only that part will receive light from the flash. The result is 'cut off' as in the shot above. Vertical shutters may synchronize at speeds of 1/125 or slower.

HEAVY FLASH SHADOW

Because the light from a flash gun is far more concentrated and direct than light from the sun, it can cast heavy, unnatural shadows. This usually happens when the subject is positioned too close to the background (see above). If the flash gun is mounted on top of your camera, and you are standing directly in front of the subject, then the problem may not arise. The shadow will be hidden behind the subject. But if you are using the camera turned vertically the flash will be to one side of the lens and the shadow will be painfully obvious.

LOSING THE SHADOW

There are several ways to get rid of harsh flash shadow. You can:
1) move the subject away from the background, as above
2) use an extension cable for the flash and hold it well above the camera
3) place the subject against a dark or black background
4) move the subject into a doorway so that the shadow is lost behind
5) move the flash, or yourself, far to one side so that the shadow falls outside the frame area
6) stand on a chair and direct the flash from above.

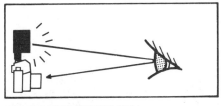

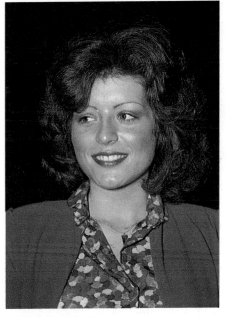

'RED EYE'

Red eye is a recurrent bugbear in all flash pictures. Sometimes it happens, sometimes it doesn't; some flash guns produce it more often than others. It often occurs when the subject is staring at the lens, with the pupils of the eyes dilated because of dim natural light. The flash light goes into the eye and reflects off the retina at the back. It will only happen if the flash, eye and lens are aligned and the pupils of the eyes are wide open.

THE WRONG APPROACH

The diagram above shows how light is reflected back from the retina into the lens. This is most likely to happen when you use a small flash gun mounted directly on the hot shoe of your camera close to the lens axis.

THE CORRECT APPROACH

If you move the flash away from the lens, you change the angle of incidence and reflection, so that the eye does not reflect light directly back into the lens. Hold the flash away from the camera by using a cable extension or use a side-mounted flash bracket.

LOOKING AWAY

Another way to prevent red eye is to tell your subject to look away from the camera. The line-up of flash, eye and lens is then eliminated. With the subject looking away you can then use your flash mounted directly on to the hot shoe of your camera.

Electronic flash guns are easy to use, but it is harder to control their effect. You can *see* when daylight is unusually bright or dim, or when parts of a picture are unevenly lit. You can also *see* ugly shadows and poor lighting from the sun or any other continuous light source. With flash, you cannot assess the lighting before you take the picture. The results can be unpredictable, unless you are sure of your basic flash techniques.

First you will know that light from the flash gun 'falls off' rapidly with distance. This happens because it is a small light source used very close to the subject, and the 'inverse square law' applies. This law states that the light on a subject *twice* as far away will be *four* times dimmer.

If you look at the diagram on the right you will see that when the light from the flash gun has travelled twice the distance it is spread over four times the area. This means that, in practice, whenever you double the distance between the flash gun and the subject, you need to open up the aperture by two stops (or increase the power of the flash accordingly).

When you are photographing several people with flash, try to get them roughly the same distance away, to make illumination even.

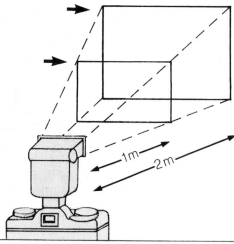

TABLE OF GUIDE NUMBERS
Work out the f stop to use for any distance with your gun's power specification, given as a guide number.
The guide number divided by the distance gives you the f stop for 100 ASA film.

GN in feet	GN in metres
160	45
125	34
100	27
80	22
66	18
56	16
45	12

MANUAL CALCULATIONS
Manual flash guns put out a constant amount of light. You set the aperture according to the distance of the subject from the flash gun. Most flashguns have a calculator dial from which to work out your exposure. This dial actually calculates the inverse square law for you. The dial is not universally applicable, however: it only works for the flash unit to which it is fitted. This is because each gun has its own stated power, given as a "guide number".

AUTO SETTINGS
Automatic flash guns put out a variable amount of light. You set an aperture on the lens according to the power of the gun. The flash gun (or camera) has a sensor which measures the amount of light which is bounced back from the subject, and cuts off the flash when the subject has been correctly exposed. These automatic flash units still obey the inverse square law, giving four times the light for double the distance. (Most can also be used manually.)

DEDICATED FLASH
Most modern SLR cameras have 'dedicated' flash guns which are intended for use with that make or model only. There are also some flash units which fit a range of cameras by means of adaptors. The basic hot shoe fitting (illustrated above) is not changed, but includes a small second contact (and sometimes a third) as well as the main one common to all flash guns. The extra contact links the flash unit to the camera's exposure and shutter controls. The method varies from make to make. With most, when the flashgun is charged this sets the shutter automatically to the correct speed for flash. It may also trigger a 'flash ready' light in the viewfinder, and set the exposure automatically.

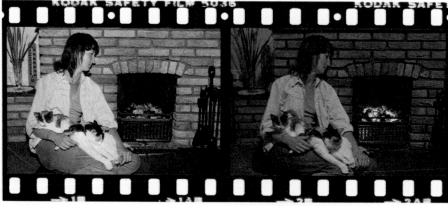

AUTO SETTINGS
On auto-exposure SLRs, the flash gun may set the lens to the correct f stop as well as setting the shutter speed. But with most makes it simply switches the camera from normal operation to flash, so that there is no chance of your forgetting to change the settings. It is still possible to get wrong exposures if the aperture setting on the gun does not match that on the camera. On some guns the film speed is automatically transferred to the flash unit from the ASA dial. The picture above was taken with a hot-shoe mounted 'dedicated' flash. Exposure was 1/60 at f11.

OVER-RIDING FLASH
With dedicated flash guns, you can shoot before the flash has recycled. In the gap between taking one picture and the 'flash ready' light coming on for the next, the camera will work just as if no flash were fitted. For the picture above, the camera set an 'available light' exposure as the flash was not ready to fire. This saves wasting a frame, but the colour balance is likely to be wrong (the household lighting—above—has given an orange colour cast) and camera shake may spoil the image. Exposure was 1/30 at f2.

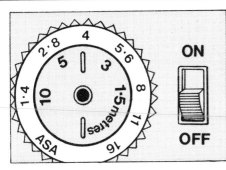

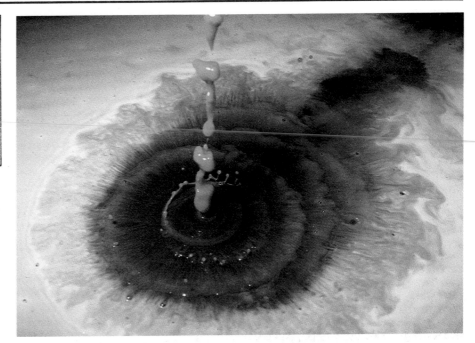

DISTANCE LIMITS

Neither manual nor automatic flash guns will give the correct results unless you keep strictly within fixed distance limits. On a *manual* gun (shown above) you can see that the greater distances need wider apertures, and shorter ones need smaller apertures. If your lens does not open up or close down to the required aperture, you cannot take your flash picture at that distance. With *automatic* flash guns, the f stop you set determines the range of working distances. Some automatic guns offer a choice of f stop settings. The wider apertures allow shooting at greater distances. The limits are usually stated clearly on the gun. If not refer to your flash gun instruction book.

FLASH DURATION

When used very close up, automatic exposure flash guns only emit a short burst of light. Instead of the normal 1/1000 or so, it can last as little as 1/30,000 sec, making possible shots like the one above.

THYRISTOR CIRCUITS

All flash guns will take a few seconds to recharge after each shot unless they include a special circuit which uses a thyristor. This saves time by keeping any charge which was not needed for the previous flash exposure.

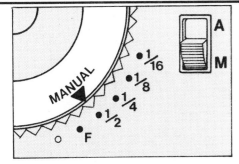

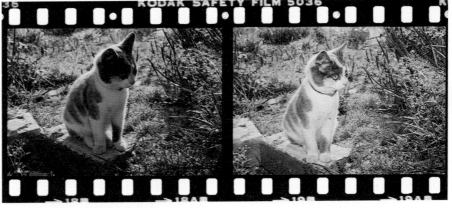

VARIABLE POWER

Some flash guns use the same circuit which controls the automatic exposure to give variable power on manual. A typical 'power ratio' dial is shown above. With the switch set to M (manual) instead of A (auto), you have a choice of full, half, quarter, one eighth and sometimes one-sixteenth power. On some guns, changing this also adjusts the calculator dial. On others you have to make the necessary one, two, three or four stop exposure compensation separately. Autowinder flash guns use this feature to give very short recycling times on low power output. This means that the flash gun can keep pace with a camera shooting at two or three frames per second when an autowinder is fitted.

FILL-IN FLASH—MANUAL

The variable power facility also makes it easier to fill in dark subjects outdoors. If a nearby subject is backlit (as above) and the background is bright, flash brightens up the main subject. Set the shutter speed for flash, and set the aperture that is needed for the background scene. Then set the manual power control on the flash gun to give the light needed for the next *widest* f stop. If the background needs f8, for example, set the gun for f5·6. (The gun will give out less light for the wider aperture.) This will make the foreground artificially bright and sunny.

FILL-IN FLASH—AUTO

With auto exposure flash guns where there is a choice of aperture, fill-in flash is also quite easy. Simply set the lens to the aperture one smaller than the aperture required by the flash gun (eg if the gun requires f8, set f11 on the lens) and check that the shutter speed that this aperture gives for the background is not too short for use with flash. (With the focal plane shutters in most SLRs, only speeds of 1/60 or slower will synchronize with flash.) You will then get fill-in flash automatically (as above).

The most natural-looking photographs are taken by daylight, whether sunny or overcast. Flash on the camera is the simplest alternative to daylight, but the effect is ugly. You need to know a little more than the basic techniques to approach the natural effect of daylight. Even holding the flash gun off the camera to one side does not solve all the problems. The flash is far closer to the subject than the sun and causes un-natural-looking shadows if it is aimed directly at the subject.

Bounce flash is a method of improving the quality of flash light. Instead of being direct, the light from a flash gun is reflected from a suitable surface on to the subject. The larger the surface, the softer and more diffused the light becomes. The light will still be coming from one direction, of course, so larger objects will still form large, soft-edged shadows, but these will be lighter than with direct flash. As on an overcast day outside, small details and projections will cast hardly any shadows at all, giving a far less jagged, angular impression of the picture's subject. It is not a good plan to use bounce flash if the ceiling is dark or high, or if the floor is very dark. Too little light will be reflected from these areas to be of any value.

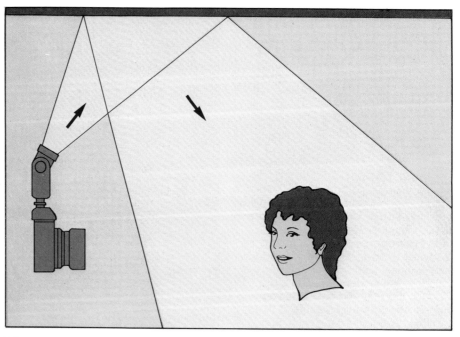

BOUNCE THEORY
For bounce flash to work properly, the reflecting surface should be positioned between the subject and the camera—above, below or to one side of the camera to subject axis. The angle of the reflecting surface is critical.

BUILT-IN BOUNCE
In the diagram above, the flash gun is mounted on the camera but aimed upwards. Flash heads that tilt in this way are a feature of many electronic flash guns and make the process of bouncing flash considerably simpler.

BOUNCE REFLECTORS
Sometimes a room is too large for the walls or the ceiling to be used as reflectors. In that case, use a portable reflector. Any light surface will do, if it is held at the right distance and angle to the subject. A matt white is best. Some flash guns have a clip to hold a small sheet of white card at 45° to the flash head. Aim the gun up vertically and the card will reflect light towards the subject. The shadows will not be as soft as when the light is reflected from a larger surface. The light is also more from the front of the subject than from above—as it would be if you were bouncing from the ceiling.

USING A CARD
For this shot, a normal flash gun with no clip was used. A sheet of white card—8in x 12in (20cm x 30cm)—was held at 45° on top of the gun with the same hand. The effect is harsher and more frontal than the ceiling bounce.

COLOUR PROBLEMS
Light bounced from a coloured surface will take on that colour and result in a colour cast like the one in the picture above. A faint colour cast may be corrected in the printing if you use colour negative film.

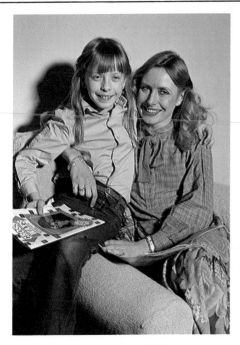

EXPOSURE CALCULATIONS

Camera-to-subject distance governed the exposure for this direct flash shot. For bounce flash, base exposure on flash-to-reflector plus reflector-to-subject distances—*plus* 1½-2 stops to allow for light absorbed by a reflector.

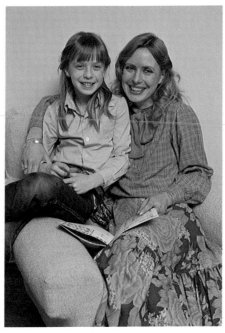

AUTO-BOUNCE EXPOSURE

With auto-exposure computer flash (as used for the picture above) you need no extra calculations. Make sure the sensor is pointing at the subject and that the distance the flash travels is within the gun's range for that f stop.

BOUNCE FLASH EXPOSURE GUIDE

To compensate for the light absorbed by the surface from which you bounce your flash, increase the aperture on the camera lens. Below are the corrections for different surfaces.

Surface	extra f stops
Brilliant smooth white paint	+ 1
Textured white	+ 1½
Old or cream paint	+ 2
Woodwork or coloured paint	+ 3

Make a further adjustment for the reflective quality of the rest of the surroundings.

Surroundings	extra f stops
Light paintwork	none
Average tones	+ ½
Dark walls and floor	+ 1

Also adjust your aperture according to the size of the room.

Room size	extra f stops
Medium room	none
Large domestic room	+ ½
Very large room, hall	+ 1
Ballroom, church, outdoors	+ 2

Add these together for final exposure (or use a separate flash meter).

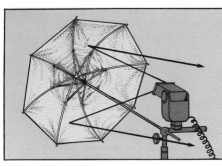

UMBRELLA FLASH REFLECTORS

The best flash light set-up for portraits is to use a flash gun and a reflector on a stand. This can then be positioned independently from the camera. The easiest reflector to use in this case is an umbrella (or 'brolly') reflector, shown above. The flash light is aimed directly back into the umbrella, which has a silver or a white surface. The light is bounced back on all sides and the effect is like that of window light. It does produce shadows, but these are soft edged. Because the whole set-up is mobile, you can position the shadows wherever you like. The shot on the right was taken with an umbrella flash, and shows good modelling on the face of the subject.

MODELLING LAMPS

A modelling lamp will help you assess how the shadows fall. Position a photoflood or domestic light bulb next to the flash shining into the umbrella. This throws the same shadows as the flash but is too weak to affect exposure.

TWIN-TUBE FLASH

Bounce flash from a ceiling can give dark eye shadows with the camera close to the subject (top). Twin-tube flash guns have a small second flash which fires simultaneously and will fill in these shadows (bottom).

Flash lighting with a difference:25

Although direct on-camera flash and bounced flash are useful for photographs which simply take a record of the subject, they are difficult to use creatively. The lighting is too raw and basic. With the addition of certain accessories, or with more sophisticated flash units, you can have more room to experiment.

One fundamental problem with using flash is that you cannot see the effect until the flash is fired—when it is often too late to change it. If you have time, you can hold an ordinary desk lamp in the position where the flash will be to see the effect of the shadows. For more accurate results, you can buy a stand which holds your flashgun next to a reflector light bulb. Studio flash has a modelling lamp built in next to the flash. Coloured filters are available for both studio flash and hand-held flashguns, and these can add life to your flash pictures. With studio flash, you can also control the spread of light with *snoots* (which cut it down to a spot), *barn doors* and *honeycombs* (both make the light more directional). There are *diffusers* which soften hand held flash, and lenses which narrow it for use with telephotos. Using either of these attachments alters the exposure so make initial tests or else use a flash meter.

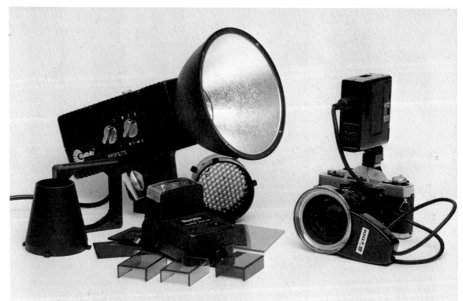

STUDIO FLASH
Mains studio flash (shown on the left of the picture) gives a full preview of the final lighting effect by using modelling lamp. Light control accessories (in the foreground) include reflectors, diffusers and filter holders. This particular model can also be converted for use with batteries.

RING FLASH
For close-up work, the circular ring flash (shown on the right of the picture) gives completely shadow-free lighting. The model illustrated is low in power and ideal for 100 ASA film. Ring flash is particularly suitable for macro photography of small subjects like plants and insects.

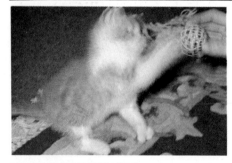

MULTI-FLASH EFFECTS
With most computer flashguns that have energy-saving thyristor circuitry, you can fire a burst of flashes with the shutter open to show a moving subject as a series of frozen, overlapping images in one frame. Any additional light should be dim, and you must be able to fire the flash very quickly. Work close-up, at about 1 yd (1m), with the widest computer aperture on the gun and the camera set at two stops smaller. Use a tripod and set a shutter speed of one-second. Then press out a rapid rhythm of four flashes while the camera makes its exposure. Hold the flash with one hand, and tap the flash button with the other. Use the delayed action timer to make the exposure (or get a helper to release the shutter).

THYRISTOR
The method of using a thyristor flash gun to get multi-images will work only with close-up subjects. At close distances the gun uses so little energy—compared with its maximum output—that one basic charge will give five or six quick flashes before it is exhausted.

DISCO STROBES
You can get a similar effect by photographing in disco strobe light, as above. Use a long exposure to catch several images of your moving subject If the strobe is fairly fast, you may be able to use the aperture recommended by your TTL meter with a one-second exposure.

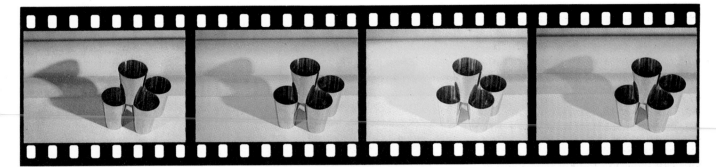

COLOURED FLASH

If your subject is neutral-coloured, like the stainless steel tumblers above, simply fixing a colour filter to your flashgun can add colour to the picture without changing the colour of the subject. Whatever form of flash you are using, you can change the colour of the light it throws: all you have to do is tape some coloured acetate (available in art shops) over the flash head. If you are using more than one flashgun or supplementing daylight, you will add an accent of colour: the overall balance is not upset and the parts lit by coloured flash stand out. Position the flash with the colour filter to one side, not close to the camera, for best effects.

EXPOSURE AND RESULTS

You need give no extra exposure with light-coloured filter material. With denser filters, it is best to bracket your shots to be sure of the right exposure. If you are using more than one flash, remember that where opposite colours—like red and green or yellow and blue—overlap, a combination close to normal white light will result. In the pictures above, one low-power white flash was aimed from the right, making a strong shadow. A flash twice as strong was aimed from the left at the same distance. This was fitted first with a red, then a blue, a yellow and a green filter in that order. The effect of the colour is best seen in the shadow areas.

FILTER KITS

Many battery flashguns which fit into camera hotshoes have special filter kits, like the one above. A kit and two flashguns gives you many effects.

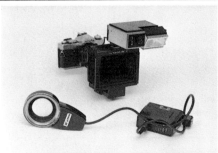

CLOSE-UP FLASH

With extreme close-ups, a hotshoe mounted flash is often aiming *above* the subject, not at it. The light may also be too directional and concentrated to give good detail throughout the depth of the subject. For shallow subjects, where a sharp fall-off in illumination does not matter, use a close-up bracket-mounted flash. There are also special filter-rim mounts, and lens-shades with a flash shoe (shown above, top of picture). For deeper subjects use an L-bracket, mounting the flash to the side and allowing angle and pitch adjustment. Ring flash (shown in the foreground) gives superb, shadow-free lighting from around the lens. It also gives consistent light with very little fall-off.

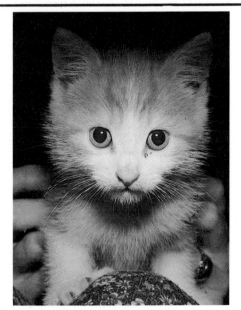

BRACKET FLASH RESULTS

The shot above was taken with the flash fixed at about 6in (15cm) above and to the side of the kitten's face. As a result there are strong shadows and a sharp fall-off of light. Both the lens and the computer flashgun were set at an aperture of f16 on 100 ASA film for maximum depth of field.

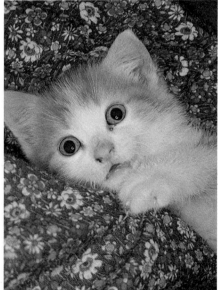

RING FLASH RESULTS

The same subject taken with the ring flash is much more detailed and evenly lit, though it has less textural contrast. The same aperture was used, and the distance remained the same. Note how the depth of the illumination is far better. The ring flash also leaves no harsh shadow.

Basic filters are simply flat glass sheets or discs which 'filter' out unwanted wavelengths, or colours of light when fitted to the lens. By using the right filter you can alter the contrast or colour of a subject to improve your pictures.

When used with black and white film, the job of a filter is to improve the *tones* of a subject. With colour film a filter is used to improve the *colour*. Use colour filters with discretion when using colour film. If you use a strong red filter, for example, you will end up with a deep red image!

Filters also have an effect on exposure. All but the weakest filters cut down the amount of light entering the lens, and so require increased exposure. The 'filter factor' (that is, the amount of increased exposure required) is usually marked on the rim of each filter.

If the filter factor is ×1, then no exposure increase is needed. If it is ×2 then exposure must be increased by one stop (ie, doubled). If it is ×4, then exposure must be increased by two stops, and so on.

You cannot always trust a TTL meter to give correct readings with a strong filter in place due to the colour response of its light sensitive cell. Check by taking a reading without a filter and multiplying this by the marked factor.

FILTERS FOR BLACK AND WHITE
The filters above are most commonly used in black and white photography. They all cut down distant haze and increase contrast, especially between clouds and the sky. The stronger they are, the greater the effect will be. From top to bottom they are: UV/haze; X2 yellow; X4 orange; and X8 red.

FILTERS FOR COLOUR
Filters for colour are usually weaker than those used for black and white. They are used to increase the depth of colour and correct unwanted colour casts in a picture.

Those shown above are: UV/haze (top); skylight 1a (right); polarizer (left); and blue daylight-to-artificial light.

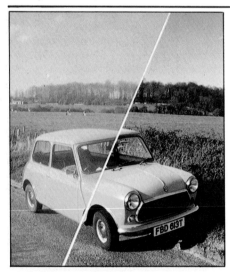

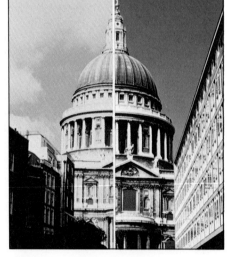

CUTTING THROUGH HAZE
Haze, ultra-violet (UV) and skylight filters all fulfil much the same purpose. They cut down excessive blue from ultra-violet rays for distant subjects and cut through haze on bright overcast days, like that shown above left. With the filter fitted the colours become clearer and brighter (above right). Because these weak filters do not need exposure increases you can leave one permanently fitted to protect the lens.

MAKING COLOURS RICHER
Using a polarizing filter can make a dramatic difference to the colours in a picture. Rotate the filter on the lens until you can see the difference in the viewfinder. Skies will appear bluer, grass greener, and the colours will generally look richer. The right-hand side of the picture above was taken with a polarizing filter fitted.

When using a polarizer you will need to give 1½ to 2 stops extra exposure.

CUTTING OUT REFLECTIONS
A polarizing filter is also useful for cutting out unwanted reflection from polished, painted or glass surfaces. It does not work if you are head-on to the surface, but at an angle you can, for example, remove reflections from a window. The right-hand side of the picture above was taken using a polarizing filter. It will also cut glare from water, and works equally well with black and white or colour film.

TO CORRECT TUNGSTEN LIGHT

Colour slide films are blanced to give correct colours only under one type of lighting. Most are 'daylight' films for normal daylight or flash, but you can buy films balanced for tungsten floodlight bulbs and cine lights. The result of using a daylight film by tungsten light is shown above—an orange cast. The blue D-to-A (daylight-to-artificial) filter shown opposite corrects this. Tungsten balanced film used in daylight does the reverse and gives a strong blue cast, needing an orange-brown A-to-D filter. Both filters need exposure increases.

TO CORRECT FLUORESCENT LIGHT

Although fluorescent tube lighting is now very common, no slide films are balanced for this. Tubes vary in colour results, but usually give a greenish cast, as above. Normal daylight film can be partially corrected by using an FL-D (fluorescent-to-daylight) filter, which is warm salmon pink in colour and needs no exposure increase. The correction is never total.

Colour negative films do not need filters, as the colour balance can be corrected when printing, but prints will be easier to make and better if you do use a filter.

CORRECT RENDERING

The picture above was taken on daylight film. The girl was lit by tungsten light. With a blue D-to-A filter fitted to the lens the orange cast which was so obvious in the first picture has been greatly reduced. Using a filter will rarely give perfect results, but the effect is much more acceptable.

INCREASING CONTRAST

Black and white film sees colour simply as tones of black and white. Blues record as 'bright' and reds as 'dark'. White clouds and a blue sky, therefore, may look much the same tone, and the contrast will be lost. You can use coloured filters to increase contrast. In the pictures above the boots are red, the hat blue, the grass green and the sky pale blue. It was taken without a filter. Compare this with those right.

YELLOW: THE BASIC FILTER

Many photographers leave a medium yellow filter permanently in place for black and white work. It corrects the tendency for most black and white films to be over-sensitive to blue. Apart from improving contrast between the clouds and the sky it cuts down haze and improves foliage and skin tones. The picture above was taken using an X2 yellow filter. Exposure had to be increased by one stop.

RED: FOR DRAMATIC TONES

The deep red X8 filter used for the picture above almost totally cuts out blue light. It also needs a full three stops extra exposure. Contrast is taken to extremes; dark green or blue objects (note the helmet) become almost black. Shadows lose detail and skin is bleached white. Haze (not fog) is almost completely eliminated. Skies can go very dark. Red is a 'fun' filter to try for effects.

There are many filter types or optical attachments for special effects—apart from those designed to compensate for the shortcomings of an image. Most of these special effects filters are easy to use, giving predictable results. In most cases, you need not alter your exposure technique: what you see in the viewfinder represents the finished result.

With some filters the degree to which they alter the image depends on the aperture used which means that you should use your stop-down preview button to check the final effect before you shoot.

Coloured filters are available in plain tints, with one half only coloured, or with the outer surround coloured and the centre clear. Some have two or three different colours, each covering a different part of the picture.

Misty filters look slightly opaque and give a pastel or foggy-day effect without making the image unsharp.

Soft-focus filters blur the outline of the image slightly, giving a diffuse effect.

Screen filters also blur the image and add rainbows or streaks of light where there is a strong light source. The most dramatic effects with cross-screen filters are produced with strong point-source lamps against a dark background.

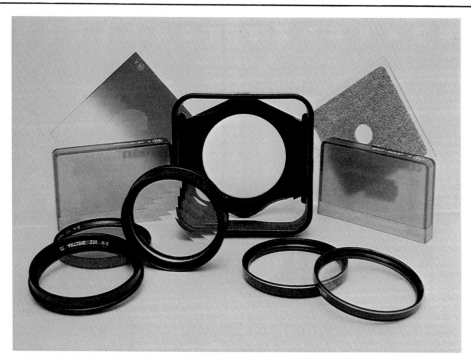

MOUNTED FILTERS
Filters mounted in screw-in circular rims (shown in the foreground above) fit only one lens size, though you can buy adaptors. They are expensive, but are of very good optical quality.

SYSTEM FILTERS
Rectangular plastic filters slot into a holder (at the back above) and cost much less. One holder fits several lens sizes and adaptors are cheaper, but the filters are easily damaged.

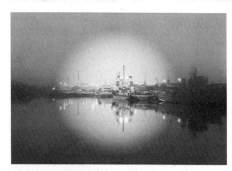

SPOT FILTERS
Spot or centre-focus filters reinforce the natural emphasis towards the centre of the picture by deliberately misting, blurring or colouring the outside edges. How sharp the central area remains depends on the filter, the lens and which f stop you use. The shot above was taken at f8 with a violet centre-spot filter. This has a marked effect, but some are far more subtle. Types of spot filter include ones which use a close-up lens with a hole cut in it to blur the outer edges optically; filters with sand-blasted or etched surfaces; coloured glass with a hole cut in the middle; and clear plastic with a pattern printed round the outside.

CROSS-SCREEN FILTERS
Filters with fine parallel lines across the entire surface produce distinctive bursts of light from any bright light sources in the picture. The light bursts follow the direction of the ruled lines, and can be altered by rotating the filter. Here the lines cross at 90°: Rules which cross at 60° produce six-pointed stars. The closer the lines, the stronger the effect. Lines 1/6ins (4mm) apart give small light bursts, and lines .04ins (1mm) apart give strong light bursts. Very fine, closely drawn lines will also cause diffusion, reducing the sharpness and the contrast of a picture to a marked degree.

COLOUR-BURST FILTERS
Ruled with very fine lines—far finer than the cross-screen filters—colour-burst filters produce patterns of rainbow colours from strong light sources. There are many variations on this idea, but they are relatively expensive. The stronger the rainbow effect, the more diffusion is produced in the rest of the pictures—in some cases as strong as the diffusion from a fog filter. The filter used above has a clear centre spot to reduce this fogging. It throws off repeated parallel images from light sources, in this case extending to the sides of the frame. Rotating the filter changes the angle of the rainbow of light.

FILTER TYPES AND FITTINGS

Screw-in mounted filters:
40.5mm, 43.5mm, 46mm, 49mm,
52mm, 55mm, 58mm, 62mm, 67mm,
72mm, 77mm

Filter systems:
Cokin 67mm x 76mm
Ambico 67mm x 76mm compatible
Hunter 67mm x 67mm
Kodak 50mm x 50mm
 75mm x 75mm
 (can be cut to fit)

Filter types:
Pure colour: available in all types.
 Made in glass, plastic, acetate
 and gelatin.
Pastel and fog: both rim-mounted and
 system types.
Graduated: both mounted and system.
Soft focus: mounted filters only.
Centre spot: both rim-mounted and
 system filters
Cross screens: both rim-mounted and
 system filters.
Colour burst: best as permanent,
 mounted filters. (System filters are
 cheaper, but may use fragile,
 flexible sheets.)
Prisms: mainly mounted but a few
 available for holders.

COLOUR FILTERS

Straightforward colour filters are ideal for creating a mood, but if you want bright colour effects—strong red or purple for example—you should choose a very graphic, simple image. When shooting in colour, you can make use of filters intended for black and white film, for colour correction, or for darkroom use to give a powerful effect. Normally, you should take your TTL meter reading with the filter in place, but if you want to boost the colour, give the exposure that you would have used if you had been shooting without a filter. But go easy with strong colours: you can always add extra colour at the darkroom stage when you are printing.

MULTI-IMAGE PRISMS

Prisms are thicker than filters—like cut glass with angled facets. They split the subject into overlapping images. There are many types, most of them giving a main image surrounded by slightly weaker secondary ones. The type used above gives a row of repeated images to the left of the frame. Prism filters do not require any change in exposure, but their success depends on the lens and the aperture. They do not work well with telephotos, and at small apertures the image weakens towards the outer edges of the frame. Prismatic filters are most effective with strongly outlined subjects and silhouettes. No exposure increase is needed with these devices.

FOG FILTERS

A fog or pastel filter looks like a clear, colourless filter that has become slightly misted. It diffuses light over all the picture, and has two main uses: Used for portraits, it softens the tones and the colours. Outdoors it gives the impression of a hazy day. Pastel filters are not as strong as fog filters, and both come in two strengths. The picture above was taken with a Pastel 2: more exposure would have given more of an impression of mist, whereas normal exposure simply gives a soft grey effect. Graduated fog filters—clear at the bottom and misted at the top—give a realistic haze to landscape pictures.

GRADUATED FILTERS

Graduated colour—or neutral density—filters allow you to colour or darken one half of the picture and leave the rest unchanged. They are usually used to put colour into a plain white sky on a dull day, as in the shot above. They can also deepen an already blue sky or add an unexpected green or pink. Grey half-and-half graduated filters are useful if one half of the picture is better lit than another. Indoors, for example, they darken the ceiling and the lights. You can also use two graduated filters together: on a dull day, a brown will warm the ground and a blue will colour the sky, with a gradual change where they meet.

SOFT FOCUS

A soft focus filter gives a basically sharp image surrounded by a diffused halo. Here the pattern on the jumper is sharp, though in the highlight areas the halo is quite strong.

Better picture composition:28

When you look at a scene, your eyes scan everything in front of them rapidly. They take in the important details quickly but catch only a vague idea of the complete scene. There is no visual effect of 'framing off' an area and then just looking at that as a whole.

The camera, however, does just this. It isolates one part, cuts out all the surroundings, and produces a rectangular (or square) picture. This is totally unlike looking at reality. The world appears condensed and flattened, into a two-dimensional design in which every visible detail counts. Ordinary things which you may not have noticed can appear important when framed off in a photograph.

Because of this, careful composition is an essential ingredient of successful photography. Better composition leads to better pictures. Accidental framing of the wrong area, can ruin an otherwise good picture.

The golden rule is: *Don't aim—frame.* Frame up your shot using the edges of the viewfinder, don't aim just using the centre. You will then avoid cut-off detail, bad positioning and crooked horizons. Look at the pattern made by the whole of the picture, not just at the point of greatest interest.

FRAMING FOR SLIDES

The outside edge of the picture above represents the whole area of a 35mm frame. But you rarely see all of this. The SLR viewfinder only shows 93% of the area (the solid line above) and mounts for slides cover up about the same amount of the picture edges.

FRAMING FOR PRINTS

If your prints are made commercially you are likely to see even less of the frame area. Most firms crop the edges as far in as the dotted line shown above. So, when framing your shot leave a little extra space at the edges or you could 'lose' important details.

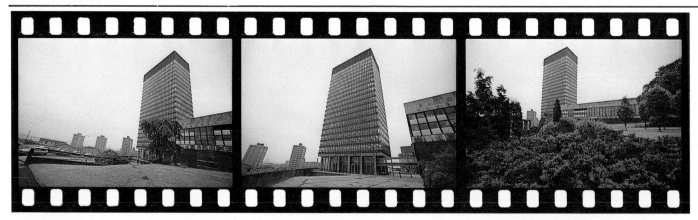

BALANCE

Balance is one of the most important aspects of composition. It takes a while to learn and involves a certain amount of instinct. But there are a few basics which can be grasped quite easily. The first thing to look out for is the horizon. If this is not level then the components of the picture will seem to tumble out (see above). It is easy to forget about the horizon if your main subject is in the foreground or middle distance, so remember to check it carefully in the viewfinder before taking the shot.

BALANCING VERTICALS

If you aim your camera upwards at a building, as above, the sides are bound to appear to converge. This can be effective but sometimes looks as if the building is about to topple over—why? The answer is balance. The shot, above left, shows an attempt to keep the building straight by making one side roughly parallel with the edge of the frame. It fails—the horizon slopes and, despite being lined up with vertical, the building looks unstable. In the picture above, balance has been achieved by aligning the verticals so that they lean equally on both sides.

BALANCING MASSES

You can reduce the leaning of a building by photographing it from a distance but the chances are that it will then fill only a small part of the frame, leaving large empty spaces. When this happens change your viewpoint slightly. Crouch down or move to the side so that you can include another element in the picture to balance the main subject in the distance. In the picture above a change of viewpoint has included the bushes and flowers in the foreground to counter-balance the building and fill the frame.

READING THE PICTURE

The eye doesn't see all of a picture at once. It wanders over it, picking out details and returning to the most interesting parts. Good composition helps the eye by linking and balancing the different parts of the picture. Good pictures 'hold' the eye so that the viewer returns repeatedly to the important details. Choose a viewpoint that emphasizes the main subject and excludes distracting details or colour from the background and edges of the picture area.

POSITIONING THE SUBJECT

Look at the two pictures of the man digging above. In the left-hand shot, the man is facing the right, and the action aims right. It conveys a different feeling from the shot above, where the direction is reversed.

Right-facing subjects seem to look 'out' of the picture. Left-facing subjects stop the eye and hold it better. The picture above looks more contained and the empty spaces are less noticeable. Try to position your subject so that it holds the rest of the picture together. Avoid putting people at the edge of the frame looking away from the subject.

VERTICAL COMPOSITION

Remember that you can turn your camera on its side to take pictures! The same rules of composition apply, only this time to a longer, narrower format. For subjects like that above, vertical composition emphasizes height.

COMPOSING FOR IMPACT

Having said that you must keep the horizon level for balanced composition, there are exceptions—especially if the horizon is not actually included in the picture. A tilt can be very effective if it looks deliberate.

In this picture the horizon was certainly not kept straight, but the impression is one of the strength and movement—even though the car was in fact stationary.

By breaking the rules like this, you can often produce a dynamic picture. But make sure the effect is exaggerated. If you deviate only slightly from the accepted rules the result may look as though you have made a mistake.

THE CLASSIC APPROACH

If you are in any doubt about how to compose your picture, you can always fall back on the traditional 'rule of thirds' (see section 2, page 9). Painters have used this system throughout the ages and the result is usually restful and easy to look at. When the main points of interest are on, or near, the 'intersection of thirds' they tend to attract most interest, but without dominating the whole of the photograph. In other words, with this system you should achieve a good balance.

The picture above is a perfect example of classic composition. The horizon is one third of the distance from the top of the frame, and it is level. The tree is one third of the way in from the right-hand edge, and the mass of yellow in the foreground balances these two centres of interest.

The best colour photographs make their impact by means of colour—as well as by good composition, lighting and technical quality. Sometimes an abstract design, which is not interesting for its subject matter, makes a good picture just because of its colour quality.

Colour has a strong effect on our emotions. Different colours can subconsciously suggest many different things: temperature, distance, aggression, and comfort can all be indicated by the use of colour. Blue, for example, is associated with coldness, distance, cleanliness, purity and the spirit. Very dark blue has deep and mysterious overtones. This may be because the sky is blue. Brown, the colour of the earth, gives a warm, reassuring, solid, natural impression. It is no coincidence that science fiction films, for example, use a great deal of blue, nor that advertisements for wholefood products use brown colours.

You can use colours to the same effect in your photographs. Choose an appropriate colour background for a portrait, for example: use a colour filter for atmosphere: or just learn to *see* good colour pictures. Study classical paintings to see how colour harmony and contrast can be used; and then develop your own ideas from there.

THE COLOUR WHEEL
The colours of the colour wheel are red, yellow, green, cyan, blue and magenta. The *primary* colours are red, green and blue. The others are *complementary* colours, made by mixing the primaries on either side.

HARMONY AND CONTRAST
On the wheel, adjacent colours go well together; opposite colours have most contrast. Mixtures of two adjacent colours (orange, for example) will clash with the mixture of the two opposite colours (that is, turquoise).

COLOUR AS THE SUBJECT
A mixture of bright colours makes a good composition with colour as the main interest. In the shot above it was essential to include the neutral coloured box to avoid overloading the picture with colour. With so many shades, colour clashes are minimized.

COLOUR HARMONY
Pictures in which all the colours harmonize are restful to look at—subtle rather than brash. In this shot the background provides enough contrast for the subject to stand out though it does not detract from the neutral tones of the horn cruet.

COLOUR CONTRAST
You can add depth, dimension and brilliance by putting a brightly coloured object, like this flower, against its opposing colour on the colour wheel. The mauve/blue gives maximum contrast: green/blue (closer to yellow) would be less contrasty.

HOW COLOURS WORK
Compare the black and white picture above with the colour version of the same subject. The black and white picture is rather pointless, but the identical shot in colour makes a strong impact simply because of the colour. It is bright and cheerful and leaps out from the page.

To get the strongest possible effect from the colours in a scene, use slow, fine grain colour film. With colour transparencies, you can get more saturated colour by slightly under-exposing the shot. With colour negatives, you will often get better results from slightly over-exposing the picture. In either case half a stop is normally enough to increase the colour saturation.

COLOUR BLENDS
The saturation of colours is mainly affected by the amount of white they contain. The colours in the picture above are complex blends of hues from the colour wheel. Each has an added brightness because it is also mixed with white.

FILM AND PRINTS VARY
With a different slide film, the colours n the shot above would have been slightly different. Prints from the same negative can also vary. To see the colour bias of a film, photograph a colour checker on one frame and compare the shot with the original.

ONE-COLOUR IMPACT
A shot which uses only one colour can be very powerful, so long as it contains an area of some neutral shade. Here the roof of the toy car offsets the dominant red. The slight variations in shades of red maintain the interest of the picture.

ACCENT COLOUR
A small area of one colour on a contrasting or neutral background attracts attention, making it the most important part of the shot. In the picture above the red button dominates the rest of the picture despite its small area.

DISCORDANT COLOURS
Some colour combinations are risky. The colours above are neither in direct contrast nor in harmony. Orange is a mixture of red and yellow: yellow is next to green on the colour wheel and red is next to purple. Together they make a lively—but discordant—impact.

Composing for depth:30

One of the most common reasons for taking a photograph is to record a scene or an event exactly as it appeared at the time—to capture what was there, which may never happen in quite the same way again.

A photograph, however, does have one major drawback. It is basically a flat piece of paper with only two dimensions. Because of this it is not always easy to convey the feeling of solidness and depth that existed in the original subject. (Many people are disappointed with their pictures because they look 'flat' and not quite true to life, rather like stage scenery.)

This need not happen. With a little thought and care you can bring out the feeling of depth in a subject, so that the size, shape, scale and position of everything in the picture stands out well and clearly.

The way to do this is by careful composition. You can change your viewpoint, and maybe even your lens, so that what you include in the frame gives 'clues' about the subject and turns a flat piece of paper into a three-dimensional image. You may have two eyes for depth perception. The camera has only one, but other means can be used to indicate depth.

VIEWPOINT AND DEPTH
Depth in a picture is increased if you shoot at an angle to the subject and not flat-on. Top: 3-D effect, using a low viewpoint and looking into the depth of the scene. Above: flat 2-D from a straight-on viewpoint—little depth.

LENSES AND DEPTH
It is easier to create impressions of depth with a wide angle lens, not a telephoto. Top: a 200mm lens compresses distance and sees this view with very little depth. Above: a wide angle 24mm, exaggerates depth.

3-D CLUES—SCALE
Use the clues your eyes use to show depth in photographs. The main one is change of size and scale with distance. Things look smaller when they are far away than they do if they are close up. In the shot above, this is the main clue to the depth of the subject. To emphasize this you can move closer to part of the scene, so that objects nearer the camera look even larger. A wide angle lens lets you get closer and still get the whole subject in the frame. The strongest sense of distance is given when there are similar sized objects both near to the camera and in the distance, or a line of them repeated, as in the shot above.

OVERLAP
Distant subjects do not have much depth visually. All the details are so far away that any difference in relative scale is lost. A person 15 metres away, for example, looks five times smaller than a person 3 metres away. But someone 30 metres away only looks half the size of the one 15 metres away. Overlapping detail, as in the shot above, is a much better clue to depth in distant subjects and telephoto lens shots. If one part of the picture overlaps another we know it must be in front of it. Change your viewpoint so that some of the elements in the picture overlap.

FRAMING THE SUBJECT
A 'frame' round the subject gives an even greater impression of depth than the inclusion of a foreground. In this shot the ground is a link between the foreground and background, but the framing archway gives depth by separating the two.

SUBJECT WITHOUT DEPTH
The shape of the monument above is clear enough, but seen in isolation the whole picture is flat. There is no interesting 'distance' in the shot. Pictures like this are simple, clear and easy to understand, even if they are small. (For this reason catalogue publishers often cut a subject out of its background.) But from this picture you have no idea of the size of the subject. Only the limited depth of the subject itself gives any 3-D effect, and even that would be lost in dull lighting and the picture would have no depth at all.

USING A BACKGROUND
By standing back and choosing a higher viewpoint, the picture is made much more interesting. A complete background scene now puts the subject in context, and gives it scale. There is much more to look at in the picture, and the impression of three-dimensional depth is increased. Empty space has been filled by scenery, but the main subject is still prominent. Good backgrounds have this effect. A badly-chosen background might have too much distracting detail. The balanced composition helps.

ADDING A FOREGROUND
To complete a scene like this, depth can be emphasized by using a foreground. Sometimes this is impossible, but by looking around you may find a suitable viewpoint to line up foreground, subject and background perfectly. For the picture above, the lens was changed to keep the subject large enough from further away. When you include a foreground, make sure it does not dominate. Brightly-coloured details are harder to use than foliage. Sometimes it is enough just to include some space in front of the subject.

CONTRASTING TONES
Light and shade also emphasize depth. By making the subject stand out against the dark background of the interior, this 105mm telephoto shot has depth despite very few other 3-D clues. It is important to retain detail in the shadow areas, so they too show depth.

DOMINANT COLOURS
As well as light and shade, colours can play a part in the impression of depth in a photograph . As a general rule bright and vivid colours look close and larger, while subdued colours look further away and smaller. Warm colours—red, yellow and orange—are the most dominant. They seem to advance out of a picture. Bright purples can also stand out. Because of this property you can use warm, bright colours to add life to a flat picture. Red in particular, will appear to leap out of dark surroundings (see above) and give a 3-D quality to the picture.

RECEDING COLOURS
To stand out at all, the colder colours—blue and green—have to be really brilliant. Normal blues and greens recede—they look further away, smaller and less dominant. Even the bluest sky never seems to dominate, whereas an area of red in a fairly small part of the frame can take over completely. Compare the effect of the two shots above. The flowers take up just about the same area in each picture but the red appears much more lively. The blue flower makes the picture much flatter.

Selective focusing is a way to emphasize the most important part of a picture by making it much sharper than the rest. The idea is to allow only enough depth of field (see section 4, pages 12–13) to cover details you want, leaving the rest a blur. The 35mm SLR is the ideal camera for this: the wide apertures available on many lenses limit depth of field, and the camera's fast shutter speeds allow you to use wide apertures even in good light. The accurate through-the-lens focusing also lets you see exactly what is in focus and what is not.

Long lenses are helpful since they have a shallow depth of field, and working close to your subject also limits the area in sharp focus. In some shots, where the subject is already picked out by shape, colour or tone, the background need be only slightly out-of-focus. In others, you may want to blur unwanted detail (such as foreground intrusions) beyond recognition.

An SLR with a depth of field stop–down preview control is desirable, allowing you to see precisely what effect your aperture has on the depth of field before you take the picture. However, practice soon allows you to judge depth of field and anticipate the visual effect of various apertures.

ISOLATING WITH BLUR
When a picture contains a great deal of highly colourful or very detailed distractions, use selective focusing to blur them. This is particularly useful in drawing attention to a face, for example, which has little colour or texture to make it stand out otherwise.

WHERE TO FOCUS
The sharpest focus should be on the most important area of detail: it should preferably contain sharp tones and shapes. In pictures of faces use the eyelashes of the eye nearest you. It is better to allow the background to blur than the foreground.

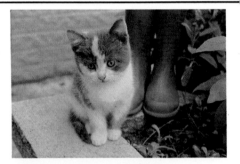

MAKING THE FOREGROUND COMPLETELY DISAPPEAR

There are times when there is no way round an obstructing fence or barrier between you and the subject. By throwing it well out-of-focus, however, you may be able to make it seem to disappear in your shot. Your aim is to blur the wire or fence so completely that it is barely visible in the final picture.

Get very close to the fence so that it is out of focus. A wide aperture and a telephoto lens (which both limit the depth of field) will be a help here to achieve this.

The first of these shots (above) made no attempt to lose the fence. It was taken at a distance of one metre from the fence at f16—a typical 'sunny day' aperture.

This shot was taken with the lens right up against the fence at an aperture of f3·5—which required a 1/1000 sec shutter speed. You can no longer see the fence. It is too out of focus to register on the film. The technique can be very useful when you are photographing at a zoo, for instance, or for some forms of sport where the arena is surrounded by a protective fence. It can also be used to minimize the effect of dust and scratches when you are photographing through the window of a vehicle. When photographing wildlife from a hide, you may also be able to lose the twigs and foliage close to the camera. Remember when limiting depth of field to focus carefully on the main subject.

A PROBLEM BACKGROUND
Backgrounds can be a problem, particularly in candid shots of people and—as in the pictures above—animals. When you can neither pose the subject against a more suitable background nor change your viewpoint, selective focusing can solve the problem by blurring the background detail that you do not want. In the first of these shots (above), the red Wellington boots distract the eye away from the kitten. Since getting an animal to pose for the camera is even more difficult than posing people, it was too risky to move the kitten to another location and hope for as good a pose. Nor was it possible to lose the boots by taking another camera angle and still keep the head-on viewpoint.

GET THE RIGHT LIMITS

When you use selective focus, make sure that the main subject is sharp all over. Use the depth of field preview button to check this, or work it out on the depth of field scale if you have no preview button. It is better to allow too much depth of field than cut it short by using too wide an aperture. Remember the rule of thumb that the point you use to focus on in the viewfinder is about one third of the way into the area of sharp focus—not in the middle. Two-thirds behind is sharp, and one-third in front.

KEEP THE SUBJECT FLAT

When the aperture cannot provide enough depth of field to cover the whole subject, try moving the subject or changing the camera angle. In the shots above, the first picture has the subject at an oblique angle to the camera. Keeping the background blurred also means there is not enough depth of field to keep the whole subject sharp. The second picture shows an alternative composition with the subject flat-on to the camera (above). This solves the problem by matching depth of the subject to depth of field.

PRE-FOCUSING

When using a telephoto lens and a tripod for wildlife or for bird shots, put out suitable bait and focus on that. The subject's head will come into sharp focus when it feeds. Lose the background with a shallow depth of field.

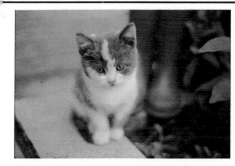

MAKING IT DISAPPEAR

The alternative was to limit the depth of field and leave the boots well out-of-focus. Though they are still as brightly coloured, without sharp detail, the blurred outline attracts less of the viewer's attention. The shallow depth of field also means that some of the kitten's body is also slightly out-of-focus though the face itself is sharp. In this case however the slight blur helps to show the kitten's fluffy coat. If your were photographing animals at a zoo, you could use selective focusing to turn an obviously man-made background into a neutral blur. At home by limiting your depth of field you can lose detail on patterned wallpaper giving an even-toned background to an indoor portrait.

CHANGING THE EMPHASIS OF THE PICTURE

Sometimes the subject of your shot may not be immediately obvious. It could be that the colours of the subject are similar to the background, in which case selective focus may be the only way to pick it out. Or—as in the two pictures above—there could be more than one possible subject for the photograph. Rather than allowing the viewer's attention to wander between one area of the frame and the other, it is better to restrict your depth of field with a wide aperture so that you only have one area completely in focus In the first shot (above), the poppies are very definitely the main subject, and the background has been left an out-of-focus blur by the use of a small aperture.

In this picture the aperture remained the same but the focus was shifted to the distant buildings. Here the poppies contribute only foreground colour to the distant scene. The effect is quite similar to the effect of focusing with our own eyes: try looking at an expansive view and you will realise that it is impossible to keep the foreground and background in focus at the same time. Switch attention from one object to another and the focus will automatically change to accommodate the new subject. We choose what is the most interesting part of the scene and focus our eyes accordingly. By limiting your depth of field, you can achieve the same effect in your camera as you do with your eyes.

Your viewpoint changes the shape and size of your subject—not in reality, but in the picture. In everyday life we are not normally aware of the way things appear to change shape as we move around them because our brains interpret what our eyes see. The brain knows that the objects around have not actually changed at all. If you deliberately look at something familiar from an unaccustomed viewpoint, however, you can become aware of the effect. Try standing on a chair in a very familiar room: the things around you will look quite different, because you are used to seeing them from standing or sitting level, and the brain finds it hard to adjust after so much familiarity.

The camera never adjusts. Move viewpoint or angle, and shapes of the objects in the viewfinder change radically. Rectangles become trapeziums, circles become ovals, small objects look larger than big ones, fat faces look thin, high foreheads look low. When you change lenses and move closer to keep it the same size in the frame, you change your viewpoint even more dramatically. The brain interprets visual images, trying to see what is really there. It cannot do this well in pictures, so use this effect to your advantage.

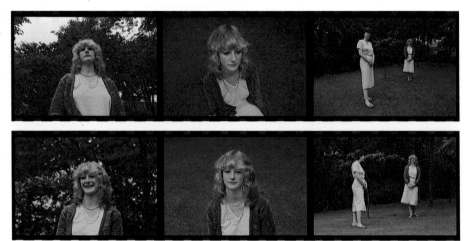

DISTANCE AND ANGLES

The difference in the effect you get when you change the angle from which you view the subject depends on how far away it is. If you are very close with a wide angle lens there is a very striking difference. In the top strip of pictures—taken on a 24mm lens—the first picture was taken with the photographer kneeling and the subject standing. In the second the positions were reversed. Note the shape of the subject's face appears to alter. In the third the subjects were 1½m apart.

DISTANCE AND PERSPECTIVE

For the bottom strip of pictures the poses were the same, but because the photographer used a 100mm lens he was working further from the subjects. The difference in viewpoint is far less marked in the first two pictures by comparison with the pair above them. The third picture, taken with the 100mm lens, shows how perspective can change with the lens you use: the subjects were in exactly the same positions as they were in the wide angle shot, though they look far closer.

SHAPE AND PERSPECTIVE

Your choice of lens appears to affect the shape of the objects you photograph. This is not due to distortion: it happens because the shorter the lens you use the nearer you have to come to fill the frame with the subject and this distance affects perspective. In the picture above, perspective is exaggerated because it was taken at close quarters with a wide angle lens. The parallel sides of the van are steeply angled as they get farther away from the camera, and the cab looks unnaturally large by comparison with the rest of the vehicle.

CHOOSING YOUR LENS

In this picture the van looks far more natural, closer to the way we would see it with our eyes. This shot was taken with a 50mm lens from farther away than the first picture. But which effect do you prefer? Whereas the picture above gives a more accurate representation of the relative sizes of the cab and the back of the van, some photographers—for certain pictures—might prefer to use the wide angle lens. The rather unnatural, exaggerated perspective serves better to catch the viewer's attention simply because it is not the way we would see it.

STEEP PERSPECTIVE OR FLAT?

This shot was taken from even further away than the last, using a 100mm lens. By comparison with the other shots, this one makes the van look quite flat, so the relative dimensions of the cab and the back of the van are almost true to life. To demonstrate the change of perspective in all three shots, imagine that the lines along the top and bottom of the van extended out of the frame. In the wide angle shot the lines would come together quite quickly, giving a very steep, dynamic perspective. In the 100mm picture the perspective is far gentler.

CONVERGING VERTICALS

Distant objects—or more distant parts of *the same* object—appear in a photograph on a smaller scale than objects close to. If the subject of a photograph includes parallel lines, they will appear to narrow as they get further away and the scale diminishes. When the subject is horizontal, like a road, the effect would be called 'good perspective'. When it is vertical, like the building above, it has a slightly dizzying effect and is called 'converging verticals'. Tilting the camera in relation to the building will exaggerate the effect. A shorter focal length lens will too because it can include more of the foreground which contrasts more strongly in scale to the distant parts.

KEEPING VERTICALS STRAIGHT

Converging verticals are most disconcerting when the sides of the building are only slightly angled by comparison with the sides of the frame. This gives the impression that the building is actually leaning backwards. To counteract this, keep the focal plane of your camera parallel to the building's walls until the verticals line up with the sides of the viewfinder. The picture above was taken from halfway up a nearby building so that the camera could be kept parallel with the building and still include some of its height. If you cannot find a viewpoint from which you can keep the verticals straight, go in closer and tilt the camera sharply up to exaggerate the effect.

DIVERGENCE

The same principle that makes vertical lines appear to converge towards the top of a picture when the camera is angled upwards, makes them seem to converge towards the bottom of the picture when it is angled down. This effect is called 'diverging verticals', and if it is very marked it can give an impression of height and even of vertigo (as in the picture above). If you are photographing from eye level in a small room you may unintentionally cause this effect in a picture, particularly with a wide angle lens and with walls and furniture close by. In a full length portrait the result might be a big head and small feet: the answer would be to shoot from waist level.

FIND A BETTER VIEWPOINT

The sculpture and the building in the picture above make an interesting subject, but are not shown at their best. The subject lacks colour and the lighting is rather dull, so all the more care has to be taken with the composition. Since the subject cannot be moved the alternative is to change the camera position. The eye level position here includes a prominent notice, an unsightly road, unwanted buildings and various other debris. All this detracts from the main subject of the picture—and need not be there.

MOVE THE CAMERA

By taking up a kneeling position, moving the camera less than one metre, the composition is improved. The notice is concealed, the subject stands out from the background, and the other distractions are eliminated.

USEFUL ACCESSORIES

A zoom lens—particularly a wide angle zoom—allows you to change distance and viewpoint and still fill the frame with the subject. And a tripod with a geared central column also helps by allowing precise adjustments to height.

Photographing people:33

People are the most interesting of all subjects. A photograph with someone in it is almost always more compelling than the same shot without the human interest. People are also the most difficult subject to photograph well. Apart from the technical and artistic considerations, the photographer has to be conscious of actions, gestures and expressions. And often the presence of the camera itself can have a disastrous effect on these. Sometimes the solution is to ask for co-operation and pose your subject: other times it is better to remain as inconspicuous as possible so that the subject behaves naturally. Occasionally you might run across a subject who is actually hostile, in which case you will need all the tact and diplomacy you can muster. Photographers who take pictures of people all the time—like wedding or news photographers—often develop a line of patter that works well for them. There may be no need to go to this extreme, but it is worth considering the best approach. Remember that the expression captured in your picture may be a reaction to *you*, the photographer. Sometimes, if people are tense, you can take a picture and then unnoticed, a second picture once they have already relaxed.

POSING FOR PICTURES
People seldom act naturally in front of the camera. Often they stiffen up and the pose becomes rather wooden. Help your subject to relax by giving him something to do — even if it is only folding his hands, or putting them in his pockets.

GROUPING PEOPLE
Avoid straight lines in group shots. Ask people to stand at different angles and distances and if possible on different levels as above. Otherwise have some of the group sitting or kneeling at the front so that you can see all the faces or raise your own viewpoint.

EXPRESSIONS AND GESTURES
Expressions and the gestures that go with them tell us more about the subject of a photograph than anything else. Even if he is obviously badly treated and hungry, a laughing child provokes a smile from the viewer, whereas a sad expression produces a sympathetic sadness in the viewer, however apparently comfortable the subject might be. Look for familiar expressions for your portraits: shrugs, winks, anger, tears, thumbs-up, fist clenching and so on. They are an instant visual language.

SITUATION INTEREST
Though shots which isolate a figure or face prominently have great impact, the subject's background or environment can add extra interest and information about the subject. When using a background in this way, try to exclude details that are not relevant to the subject, or blur them by focusing selectively (see section 31, pages 66–67). Make sure that the subject is not overwhelmed by the background: a wide angle lens will make your subject appear relatively larger by comparison with the background.

INTERACTION
Wherever two or more people are talking, arguing, haggling, joking or working together, there are opportunities for good pictures. Couples make appealing shots: so do mothers and babies, teachers and children or teams of people working or playing a sport. Look out especially for contact between the subjects — either eye-contact or physical contact, like a protective hand on the arm or a handshake. Or show how one is reacting to another by waiting for an animated expression or telling gesture.

THE RIGHT APPROACH

Never try to pretend that you are not taking a picture of someone when it is clear that you are: this only creates tension and even hostility. Most people will agree to have their picture taken — perhaps after some initial protestations — and are quite flattered by it. But they are likely to become rather self-conscious and you may need to direct them. The picture above is spoiled by the fact that the subject is looking rather aimlessly out of the picture so that the interest lies elsewhere — where she is looking.

EYE CONTACT

A picture gains immediate impact if the subject appears to be looking at the viewer of the picture. Ask your subject to look into the lens — not neccessarily to smile as well — and this is the effect you will get. The subject may not be able to do this for too long: he may become self-conscious or be distracted by someone nearby. So remind him once more, just before you release the shutter. Or try saying something funny or unexpected as you take the shot for a genuine reaction rather than a meaningless stare.

CANDID CONCENTRATION

An alternative to direct eye contact is for the subject to concentrate on something within the picture area. Your subject might find this easier to do, and the viewer can follow the attention to another part of the picture. The picture above clearly demonstrates this link, and though the subject obviously knew she was being photographed it is a candid picture: you get the impression that you are observing her unnoticed. Candid shots have a special fascination, and the subject's expression is vital to the picture.

PEOPLE AND PLACES

Many pictures of people are taken on holiday or during an outing — partly to show the place they were visiting. A little care will greatly improve this type of picture. To show people against a relevant background, use a standard or a wide angle lens and move far enough back to get the whole building (or mountain, or lake) in the frame. Ask your subjects to come fairly close to the camera and compose the picture so that the group forms a foreground interest without obscuring the background. If you can find a slightly elevated camera position, this will be far easier to do. The picture above shows a balance between the subjects and the place they were visiting, so that both claim an equal share of the viewer's attention.

TO POSE OR NOT TO POSE?

In answer to this question, first decide why you want to take the picture. If you are taking a picture to remember someone by — someone you may have met briefly on holiday, for example — then you will want a good, clear picture and it would be worth asking the subject to pose against a well-chosen background. Pictures of the family, on the other hand, can be very tedious if they are a succession of formal poses in front of places of interest. Candid pictures of events as they happen are far more lively, and you are more likely to get unself-conscious shots when you know the subjects well. The picture above was taken on the spur of the moment, and in future years will jog the family memory far better than a posed portrait.

Portraits of people:34

Any photograph of a person can be called a portrait, but normally the term only covers deliberately posed pictures. A portrait *portrays* the subject: it may show only what the subject looks like—as in a passport photograph—or it may include details that can sum up their character, life-style or occupation, or even their environment.

Formal portraits are usually taken indoors, often in a studio. The composition, pose and content of a formal portrait are all well-established: the choice is between 'head-and-shoulders', 'full-length' or perhaps seated, three-quarter length poses.

Informal portraits may be in or outdoor shots, often taken at the subject's home using natural light with the subject in any normal, relaxed pose—even walking around. With pictures like this, the intention should be to show the subject as he usually looks rather than how he would like to look for a formal portrait.

Environmental portraits should have a background chosen to inform the viewer about the subject. You might photograph a mechanic at his workshop, or a keen gardener against his flowers. A painter in front of his canvases or a sculptor with his statues are typical examples of this technique.

USING THE SURROUNDINGS
Use both foreground and background to frame your subject with relevant information about them. The picture above shows a couple at work: though they are surrounded by detail, the composition makes them stand out.

DOUBLE PORTRAITS
This picture lays equal stress on both the subjects by positioning them together at the centre of the frame. A double portrait where a close relationship or teamwork are involved works best if the subjects are touching.

HEAD-AND-SHOULDERS PORTRAITS
A picture with both head and torso turned directly towards the camera tends to look like a passport photograph — or even one taken for police records! Allow your subject to relax in a chair, perhaps resting their elbows on a table, and give a few simple directions. Say 'Look over there' to get them to turn their head, and then 'Without moving your head, turn your eyes back to me' to restore eye contact. (If you just say 'Now look at me' they will probably turn the whole head back.)

TIPS ON POSING
The picture above looks far more natural and relaxed than the one on the left. Three main changes have been made. Firstly, the subject is seated sideways on to the camera, which slims the body. Secondly, the head is turned back to face the camera, but not so far that both ears are included. Thirdly, the subject was asked to lean slightly forward to give her head and face a slight angle. You may not want to follow this formula exactly, but think of ways to vary the direct, head-on position.

FULL LENGTH POSES
Avoid straight standing poses: these do not fit the 35mm picture shape. Leaning with the weight mainly on one leg looks better, as do seated poses. Try the legs crossed, arms folded, or one hand in a pocket. Check that the lighting is even and don't forget the expression.

EYES ARE CRUCIAL

In any portrait the eyes are the most important detail. You should focus on the eyes and ask your subject to look directly at the camera. Try to avoid heavy shadows under the eyes (as in the picture above). Outdoors, these are just as likely on overcast days as in bright sunshine, so make sure your subject is not inclining the face downwards. Avoid squinting by shooting into the light when the sun is strong. Indoors, organise your own lighting with these points in mind.

CATCHLIGHTS AND REFLECTORS

Catchlights are small pinpoints of light in the pupil (as above) which add sparkle to a portrait. Indoors, a window facing the subject supplies them, but take care: more than one catchlight looks odd. Even in backlighting you can add catchlights by using a flash gun to balance your other lighting. This will also help by filling in unwanted shadows. Another way to fill in shadows is to use white card or a sheet to reflect the main light back on to the subject.

INCLUDING THE HANDS

Like eyes, hands are also very expressive in a portrait. However, they often look ugly if they are posed badly or too close to the camera. Avoid tight fists or widely spread fingers: keep them tidy and relaxed.

CAMERA ANGLES

Most portraits are taken full-face or threequarter profile, with the camera level with the face (or slightly lower for a full length shot). Move the camera for more arresting shots. Profiles like this need less careful lighting and also work well in silhouette.

LOW VIEWPOINTS

A low viewpoint will make a weak chin look stronger and makes the nose seem broader but shorter. It emphasizes the eyes, increasing the space between the eyes and eyebrows. The whole face seems to look more rectangular. But take care with the gaping nostrils!

HIGH VIEWPOINTS

A high viewpoint reduces the size of the chin and emphasizes the hair and the forehead. It tends to slim a wide nose and makes the eybrows stronger though the eyes may be shaded. It also makes the face look rather triangular, with chin much narrower than the forehead.

Any picture of people which is not posed and where the subject is not aware of the camera is a candid shot. People photographed candidly are usually more interesting because their actions, gestures and expressions are not modified for the benefit of the photographer. Curiously, however, the best candid shots are as popular with the subjects themselves as with other viewers. They are often very sympathetic, or humorous, and they reveal character. Unkind candids—which show off-peak moments or physical faults—only make the photographer's job more difficult next time.

Few people really object to being photographed, and some—extroverts and local 'eccentrics' positively expect it, which can be counter-productive for the candid photographer. Take your candid shots quickly and with no fuss. Tourist areas, where people expect to see a number of cameras not necessarily pointing at *them*, make the best locations for candid shots of strangers. Take as little equipment as you can. Instead of a camera bag take your equipment in an ordinary holdall and mingle with the crowd. One good plan is to show interest in something near your real subject and pretend to be photographing that—as described in this section.

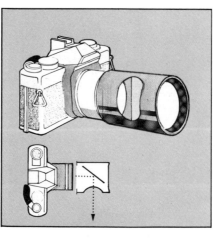

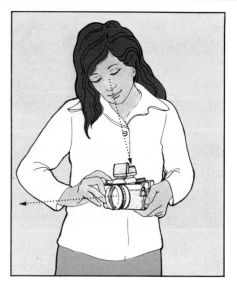

MIRROR ATTACHMENTS
The right angle mirror attachment is specially designed for taking candid pictures without being observed. It will fit most lenses of focal lengths from 50mm to 200mm. It is made to look like a lens hood or part of a longer lens—except for a large round hole in the side. A mirror at 45° to the camera turns the image received through this hole by 90° so that you can shoot at leisure, aiming the camera away from your actual target at right angles. But the picture you see is reversed.

WAIST-LEVEL VIEWS
Some SLRs have interchangeable viewfinders, and to these you can fit a waist-level viewing screen. It gives a picture clear enough to be viewed from above, with the camera held casually, using the focusing scale on the lens. Viewfinder attachments turn the image through 90° so that you can view it from above. The more expensive type gives the picture the right way round.

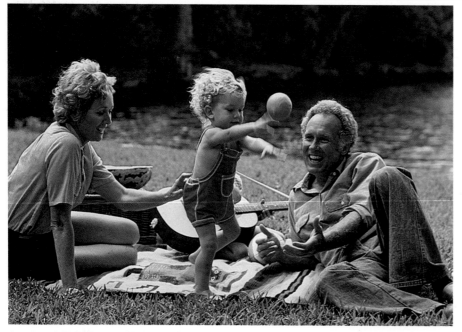

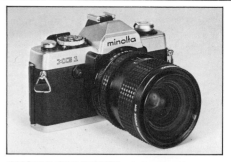

CHOICE OF LENSES
Standard lenses have wide apertures which allow you to photograph in dim light without startling flash.
Wide angles allow you to get close to the subject and keep him in focus. They also take in people at the edge of the frame who do not suspect they are included in the picture.
Telephotos cover a very selective area and you may find you have to keep your eye to the viewfinder to judge what is in the frame. But they do allow you to keep your distance.
Zooms are very useful since they mean that you can alter the size of your subject without attracting attention by moving around. The camera shown above is fitted with a medium zoom (35-70mm), ideal for candids.

HOME GROUND
Candid pictures are easier when your presence with a camera is accepted—with friends or at home. Carry your camera regularly and people will forget that you have it. Use it when attention is diverted.

CHILDREN
With small children—especially toddlers—no amount of familiarity prevents them from 'playing up to the camera'. Treat your own children like strangers and shoot your best pictures when they are completely unaware.

MISLEADING AIMING
One way to work openly while leaving your subject unaware that he is being photographed is to aim deliberately wide. Let it appear that you are photographing something beyond your real target. Do not look directly at your subject (except when you have the camera to your eye, when the direction of your glance is less obvious). Aiming at your mythical subject, include part of your real subject at the edge of your viewfinder (as in the picture above). Make sure that this focusing detail is in the same plane as the face of the subject and that the depth of field is sufficient to cover the important areas. You can take your time over this as long as the subject does not begin to suspect.

...AND REFRAMING
Then swing your camera gently round to recompose your shot to include the whole of your real subject (as in the picture above). Even if the subject has noticed you to begin with, by this time he should have lost interest in the camera. If you want more shots of the same subject, return to your decoy subject once more to adjust the camera controls, perhaps taking some shots to complete the illusion. If you are found out, a direct, confronting expression can add impact to your picture. Even though the subject is now aware of you, make sure he has no time to rearrange his expression. Shoot immediately, then shoot again to catch the subject's reaction. And then be prepared to explain yourself!

GETTING TOO CLOSE
Few people believe that you can take their picture from less than 3 feet (one metre). With a 24mm or wider lens you can include people who think you are shooting right past them. Use this to get close, immediate shots in crowds.

TELEPHOTO TECHNIQUE
A long telephoto, like a 500mm lens, is inconvenient to carry about, particularly if you are trying to be unobtrusive in a crowd. It is also hard to aim and focus quickly for instantaneous candid shots. It does have its uses for candid photography, however, though it calls for a different approach. Find a suitable vantage point in an inconspicuous place and set the camera up on a tripod.
Focus the lens and wait for the shots you want to materialize. One advantage of using a lens as long as the one used for the picture above is its shallow depth of field. This means that you can isolate the subject clearly against a confused or irrelevant background by differential focusing.

'PORTRAIT' LENSES
Short telephotos, like the 85 or 105mm lenses, are ideal for pictures of people. They are as convenient to use as a standard with a shallower depth of field and a closer, more intimate view of the subject than he suspects.

BLACK AND WHITE BENEFITS
Candid shots in black and white tend to look more 'newsy' and immediate. There is no colour to distract from expressions. It is also easier to crop and blow-up the best parts of off-the-cuff black and white candids.

You can go hunting for good landscape pictures in most parts of the country at any time of the year. Not all the best scenic views are taken in high summer in bright sunshine. Autumn colours, delicate spring foliage, frosty branches, mist or snow make fine landscapes and very attractive pictures.

To be a good landscape photographer you must be prepared to walk—in all weathers. You cannot expect to see and take worthwhile views from the inside of your car. If you do catch sight of an exceptional view, the chances are that by walking a few hundred meters you can improve on it enormously.

So once you have arrived at the area you want to photograph, pack just the camera gear you need and *use your feet*. A tripod is cumbersome, but it is a help if you want to ensure sharp pictures with the maximum depth of field. A range of filters will vary the effects you can get— graduated filters to darken the sky, or filters that intensify the colours of the landscape. You should also take plenty of film, but there is no need to weigh yourself down with your flash gun, for example, or a motor-drive.

When you get a good day, with perfect clouds and lighting, make the most of it; take many pictures.

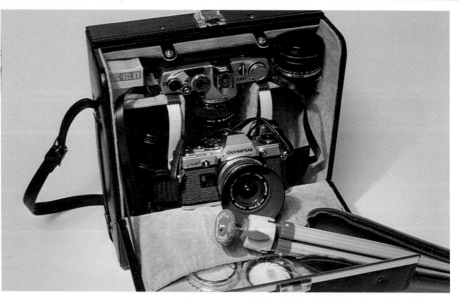

EQUIPMENT TO TAKE

A light tripod with spiked feet is useful as it lets you use long exposures: hang it in its case attached to your camera bag or belt. A 50mm lens, a wide-angle and a telephoto zoom are ideal lenses, and a teleconverter may be useful. Take a light camera holdall which you can open and use while it is still slung on your shoulder.

CASES AND BAGS

If you find a holdall too bulky, use separate camera and lens cases with neck straps. The 'ever-ready' type of case protects the camera against knocks it may get while you are climbing or walking. You can wear one lens slung (bandolier style) over each shoulder. Photographers' jackets, with large strong pockets, are also available.

PROBLEMS WITH LONG EXPOSURES

Slow, fine grain films give landscapes an extra quality. They also require good depth of field and small apertures, so you may well need to use long exposures. Landscapes may *look* still, but there is always some movement. Water in streams, grass, trees or even clouds blown by the wind: all these make long exposures tricky. On 25 ASA film at f22 and with a polarizing filter, you may need a shutter speed of ½ sec, even on a sunny day. This is long enough for a slight breeze to blur foreground foliage or grass. Try to use this creatively, allowing the water or the rippling grass to make fluid patterns across the frame.

FILTERS FOR HAZE AND UV LIGHT

The distances involved in landscape pictures lead to the problem of haze, which obscures the view progressively into the distance. If the scene looks hazy to the eye, then it will look hazier in the photograph. Even scenes that look clear may seem hazy and rather blue in a picture, because film is more sensitive to blue and ultra-violet (UV) light than the eye is. It is therefore vital to use a haze-cutting filter—a UV, skylight, Haze 1a or 1b, or a polarizer. For black and white, use a yellow filter, or, for stronger effects an orange or red filter. Any of these precautions will help to bring clarity to distant views.

THE RIGHT LIGHT
Light makes or breaks a landscape photograph. A scene that impresses you because of its sense of space and scale may often lose its impact in a two-dimensional photograph. Strongly-angled light can help give the landscape more depth, picking out the texture of a ploughed field, for example, and throwing details into sharp relief. If the light is dull, confine your landscape pictures to scenes with foreground interest or return when the light is stronger or from another angle.

EXPOSURE READINGS
The quality of light alters the contrast and the colours in your pictures. Look at the shots above: the sunlit scene on the right is much more colourful than the picture taken when the sun was obscured, yet the two shots were taken within a few seconds of each other. Exposure readings are crucial. When the sun is shining, use your normal overall reading from the TTL meter. When it is not, the fact that the sky remains bright causes the TTL meter to under-expose the duller landscape.

COMPENSATING FOR THE SKY
In both the shots above a normal—averaging—TTL meter was used. As a result, the picture taken when the sun was behind the clouds is under-exposed. To restore full exposure to foreground detail, aim the camera downwards and take your reading from the ground, leaving out the sky, and retain the reading when you take your intended picture. If you are in doubt about the reading, bracket your exposures, but always err on the side of over-exposure with negatives.

USING THE FOREGROUND
When you walk down a country road, the distant view remains the same but the foreground is constantly changing. One picture may have a tree in the foreground, and another a combine harvester, but both have the same view behind. The pictures above were taken only yards from one another. The foreground of the one on the left shows signs of habitation in a quiet valley between the mountains. The one on the right shows the same mountains in the background, but the grassy hillock emphasizes the wild countryside.

DEPTH OF FIELD
Controlling 'depth of field' (ie how much of the picture is recorded in sharp focus) is very important in landscape photography. If you use nearby objects in the foreground, you have to set a small aperture to keep both foreground and landscape sharp (see section 31, pages 66–67). Lenses which stop down to f22 are ideal. The alternative is to use the unsharpness that results from a shallow depth of field. Either way, use your depth of field scale on the lens or stop-down preview button to check.

FRAMING THE VIEW
To avoid too much blank sky—in vertical pictures like the one above, or if you want to exclude a distracting foreground—find a suitable frame for the view. Use a tree or an arch, making sure that the frame does not attract more attention than the scene itself. By including the area where the frame and landscape meet, the shot gains depth.

Don't assume that the best pictures are always taken on bright, sunny days. Pictures taken in sunshine are often quite bland and have little atmosphere. Landscapes and city scenes benefit from *dramatic* weather, rather than *good* weather. A change in the weather means a change in the quality of the light, and light is what creates shape and texture, colour and contrast in your pictures. Often the best weather for photography occurs in changeable conditions: sunshine on newly fallen snow; sun through rain, giving a rainbow. When the sun appears during storms you get the most dramatic shots of all.

Rain brightens textures and reflects back the light so that dark, dull or flat surfaces become glossy and show detail.

Snow hides small, distracting detail and smooths the overall shape of the land.

Fog masks detail too, and increases the feeling of depth in a picture. The objects in a scene become paler and paler with distance.

Wind sways trees and grass in a common direction, and improves pictures of falling rain or snow.

There are no really bad or unsuitable kinds of weather for photography, just opportunities for achieving different effects.

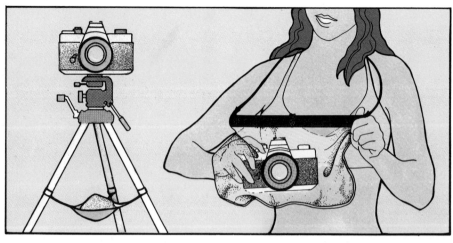

SECURING YOUR TRIPOD

A tripod with spiked feet helps to give a secure grip on wet ground or in wind. Some types have wide-splayed legs for extra stability. In wind, fill a bag with heavy stones and sling it underneath your tripod. If the wind is strong, keep the neckstrap on, even when the camera is on the tripod, in case it blows over. Use your body to shield the camera from high winds during long exposures. This, and gentle pressure on top of the camera with your hand, cuts down vibration.

WEATHERPROOFING YOUR CAMERA

There are some ready-made weatherproof cameras, but these are not SLRs. To protect an SLR against rain, snow or spray, you can buy a housing intended for underwater photography. It is bulky to handle but gives complete protection. Otherwise you can buy a weather cape. These open at the back for easy use: you can change films without removing the camera.

To cut costs use a polythene bag with the lens protected by a filter.

SNOW

Bad weather tends to keep many photographers indoors. The exception to this is snow, which brings about such a dramatic change to the landscape that it becomes a subject in itself. This transformation requires different camera techniques. First, you can afford to load your camera with slower film because the snow reflects the daylight, boosting the light level. Second, you can no longer use your TTL exposures for bright sunlight, without adjusting them. Presented with large areas of white, your TTL meter will recommend exposures that would reduce white to mid-grey. For white snow give two stops *extra* exposure. For correct skin tones, take a reading from your hand in front of the lens.

MIST AND FOG

As with snowscapes, pictures taken in fog require more exposure than the TTL meter recommends. Open up by one or two stops to keep the mist areas white rather than grey.

REFLECTED BACKLIGHT

Look for low sunlight reflected off wet ground, and use the exposure given by your TTL meter for the overall scene. This gives the dramatic effect of objects silhouetted on bright areas.

FLAT LIGHTING
A dull, overcast day gives you a flat, low-contrast light. Colours may be colder and less brilliant, with less distinction between them. With slide film, you will get best results by giving minimum acceptable exposure. Contrast and colour will look better in a slightly darker picture, though for a softer, diffused effect give *more* exposure. With colour negative film in flat light, the best exposure is that which your meter recommends. Films with good contrast (like Kodacolor 400) will enliven shots on dull days. A warm-up filter such as an 81A will cut out the cold blue tones. A graduated filter will add a fake blue sky in place of white. Look for warm red and orange foreground interest.

CONTRASTY SKYLIGHT
The most difficult type of dull day is when the sky overhead is overcast but there is a window of sunlight on the horizon. The distant brightness makes everything nearby look very dark as in the picture above) and can seriously distort TTL meter readings. If you aim away from the bright area there is no problem. If *you want to include* sunlight in your picture, you should always take your meter reading from the ground or with the camera turned away from the bright area. Be careful not to include too much sky in the final shot or flare may spoil the rest of the picture. One essential item for conditions like this is a lens hood. And you can use fill-in flash in just the same way as when the subject is backlit.

LONG EXPOSURE PROBLEMS
In winter, some days are so dark that with medium speed films, your exposures are too long to hand-hold. You will need to use a faster film—or a tripod. If you are forced to use long exposures look hard at the scene for unwanted movement. Moving cars and people, or trees and foliage blown by the wind, can spoil your shots. Do not hesitate to use a wide aperture on distant scenes where depth of field is less of a problem. If necessary, uprate your film for shorter shutter speeds. Plan important photography for the middle of the day and avoid the two hours after sunrise and before sunset. During very stormy weather, exposures may need to be as long as those used during a summer twilight.

FALLING RAIN AND SNOW
Using fairly slow shutter speeds you can record drops of rain and flakes of snow as they fall, as streaks across the frame. Shutter speeds of 1/30 to 1/125 will often show blur—depending on the speed at which the rain or snow is falling. For longer streaks, you will need a tripod and speeds from 1/15 to 1 second. Exposure speeds longer than 1 second will show the rain or snow as an overall grey veil and lose the effect. Speeds of 1/500 or 1/1000 will freeze the motion and look too artificial. Rain is more difficult to show than snow because it is colourless and transparent. In the picture above, backlighting has helped by making the individual drops sparkle. The shiny wet rail adds to the impression.

SUN AND RAIN
Strongly backlit by the sun, rain can make your pictures shine. Or with the sun behind you look for a rainbow in front. With slide films, give a ½ or 1 stop less exposure for saturated colour.

RAINBOWS
In the picture above, a 24mm wide angle lens was used. Use a *long* lens if only part of the rainbow is visible or if you want to show the colours more clearly.

There is often more variety of colour and texture in a cityscape than in a country landscape. Pictures of a city can vary from a long view of parallel rooftops to close-ups of street signs.

For street-level pictures, when space may be restricted, a wide angle lens is extremely useful. On the other hand, a telephoto lens can be used to 'concertina' the already close-packed buildings. It may be difficult to get an unobstructed view with a telephoto, unless you take a high viewpoint.

Every town and city has its landmarks. Including a famous building or statue helps to pinpoint the scene. But take care that your pictures do not turn into a series of impersonal, postcard-type views. Include some human interest—or find some bright, effective detail—to give your pictures some individuality. A stormy background or a rainbow can give some all-too-familiar scene extra interest.

You need no special equipment to photograph cities: only extra care with security. Don't carry your camera over your shoulder and behind you on its strap. It is extremely easy for a thief to cut the strap without you noticing. Drab or inconspicuous equipment attracts much less attention than expensive-looking, flashy chrome and leather.

HUMAN INTEREST
In busy city streets, people are less likely to notice a photographer. With a long lens it is quite easy to catch candid groups like the one above: shops, markets and pedestrian precincts are the best locations to find human-interest pictures.

AN ABSTRACT APPROACH
Look up at high buildings for pictures that take advantage of abstract patterns in modern architecture. Make use of reflections in plate glass windows. A telephoto zoom helps to pick out detail: this shot was taken with a zoom set at 210mm.

FINDING A FOREGROUND
In most towns there are large areas of blank tarmac and concrete—hardly an inspiring foreground, as you can see from the picture above. If you are using a wide angle lens, which emphasizes the foreground in any picture, an expanse of empty pavement may dominate the shot. You may be able to tilt the camera to cut out the foreground but this will also exaggerate the problem of converging verticals in the buildings in the background. Another answer is to find some foreground interest.

CHANGING VIEWPOINT
By changing the camera position by only a few meters and taking a lower viewpoint, the picture was dramatically improved. With a wide angle lens, a fairly small object or area will fill the empty area of the frame, and you can keep the whole picture in sharp focus. With a telephoto lens, throw objects close to the camera out of focus by using a wide aperture. This will often help by filling the empty foreground area with a blur of colour, though the details of the foreground may be unrecognisable.

COMBINING THE ELEMENTS
This scene combines several elements in one picture: in the background there is a notable landmark, which places the shot geographically. In the central area there is a group of people to add human interest. And in the foreground, the flowers and bicycles make an interesting pattern.

10am

1pm

4pm

7pm

TIME AND LIGHT

The time of day has a more critical effect in a cityscape than in an open landscape. With high buildings lining each side of the street, the sun may reach the pavement only for an hour or two each day, and one side of the street or the other will probably be in deep shadow at all times. In the evening, when the sun catches only the tops of the buildings and only reaches the ground in large open spaces, most streets will be totally in shadow. The four pictures here were taken from exactly the same viewpoint but at different times of the day. The one above was taken at 10am with the sun over the photographer's right shoulder.

BUSY OR QUIET

Not only the light changes as the day goes by. At midday there are many more people on the streets for the photographer to contend with. In the picture above, taken at 1pm, a push-chair was parked firmly in front of the camera. Pick your time for photographing city streets with this in mind. If you want to show mainly the streets and buildings, choose a Sunday, or the day of the week when shops close early. If your intention is to show the streets busy with hurrying pedestrians, find a high vantage point (such as a window) from which to take your pictures, rather than attempting to shoot in between the jostling crowd.

SHOOTING IN THE SHADE

Sometimes it is better to wait until the street is entirely shaded than to try to expose for sunlight and shadow. At dusk, you may be able to balance shop-lights with the light in the sky.

CITIES BY NIGHT

City scenes that look drab, or are spoiled by some ugly intrusive feature by day, can come to life after dark, when much of the disfiguring detail is hidden. The picture of the fountain above, taken in daylight, is something of a failure. The colour is very neutral, the background overpowers the subject itself, and the vehicles passing by add nothing to the scene. The same view by night, on the right, benefits from the coloured lights around the fountain, from the street lights behind, and from a scattering of neon signs. For shots like this you need a tripod: the exposure here was 8 seconds. More exposure would have shown more detail in the dark areas but allowed the lights to burn out.

CAR TRAILS

When vehicles move across a picture during a long exposure, their lights will draw trails of light across the frame even though the vehicle itself will not appear. Time your exposure so that the lights make a complete pattern, visualizing the effect.

GHOST PEOPLE

Long exposures can make people disappear completely if they move while the shutter is open. An exposure of 20 seconds will 'lose' anyone walking across the scene. People who stop in the middle will appear as faint ghostly images.

Photographing inside buildings:39

Most people spend more time indoors than out, but few pictures are taken inside buildings except studio or flash portraits. But indoor scenes and architecture can make interesting photographs, and the techniques are not difficult. All you need are a wide-angle lens, a tripod, and perhaps a flashgun. Unless you can guarantee to keep the camera level by eye, a small camera-top spirit level helps as well. Some tripods have these built in. Public buildings, churches, stately homes and ancient monuments are obvious indoor subjects—so long as taking photographs is permitted. But your own home is also interesting to photograph. Furniture, decorations, and the people who live there make fascinating subjects. Take a picture of your living room *before and after* it has been redecorated. Take shots of the view through the window as the seasons change.

Try recording a day in the life of your own household—far more interesting than a posed family portrait. Or take a picture every year to record the changes that have happened around your home—including a growing family in their seats around the table. Some subjects, such as cutting the birthday cake can become family traditions. Such pictures grow in value through the years.

LEVELLING THE CAMERA
Keeping the camera level is important in most shots of interiors because of the dizzying effect of converging verticals when the camera is tilted. Some people find it easier to level the camera by eye than others. Your tripod may be fitted with its own spirit level, but if not you may find it worth investing in a spirit level like the one above, which fits into the hot shoe. This helps by letting you adjust the tripod without constantly checking the viewfinder.

CHOICE OF LENS
A 24mm wide angle is the ideal lens for room interiors. A 35mm (top) covers too little. With a 24mm (bottom) you could show three out of four walls. A 20mm lens takes in even more than a 24mm.

CAMERA ANGLE
A camera held level at the height of your eye when you are standing includes too much of the ceiling in most rooms. If you angle it downwards, as in the shot above, the walls appear to lean outwards in an unpleasant way and the whole room seems to tilt. The best height for the camera is halfway between the floor and the ceiling. Drop the camera to about 3 feet (1 metre) if you want to include more of the floor, and use it at eye level if the ceiling is of particular interest. Shooting from the corner of a room makes it look larger. Shoot through an open door or window for extra distance, or right up against a wall with a waist level viewfinder.

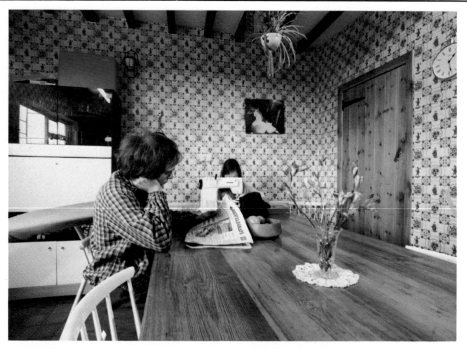

VERTICALS
For this shot the camera was carefully aligned to avoid converging verticals (see section 32, page 69). Check whether the verticals are straight against both sides of the frame.

PEOPLE AND SCALE
A figure will give a room a sense of scale. Position the figure midway across the room. A seated figure adds to the feeling of size and space in the room being photographed.

USING DAYLIGHT

If the room is light enough, use natural daylight. Avoid including large areas of window, however, since this will influence exposure. Take your reading from part of the room that has average illumination—neither a dark corner nor an area next to the window. Bracket your exposure to be sure of results. The chief difficulty with using daylight is when there are shafts of strong sunlight streaming through the windows. These create harsh highlights, so choose a time of day when the sun is not shining into the window, or wait for an overcast day. Sometimes you can add a little more detail and atmosphere to the picture by switching on the roomlights.

USING FLASH

First check whether your flash gun covers as wide an area as your wideangle lens. If you are including a window, try to match your flash to the exposure required by the scene outside. Set the shutter speed for flash then see if you can get the same apertures that are needed for the outdoor light. If not, close the curtains. Check that there are no windows or mirrors to reflect the flash back into your lens. Position the flash above the camera, as close as possible. Watch out for ugly shadows—particularly from ceiling lights. Direct flash was used for the picture above: It shows more detail but lacks atmosphere. A better solution is to bounce your flash from the ceiling.

STAINED GLASS

Take your TTL meter reading for the glass, not the rest of the interior. Go close to the window and take a reading for a medium-toned area of the glass. Use this for pictures of the glass, *not* if you want to show the whole interior.

COLOUR BALANCE

The lighting in most rooms has been arranged to make them look their best, so use it for your photographs whenever you can. Photofloods are ideal for giving extra fill-in light. Or to boost the light level, you can replace the bulbs in your light fittings with Photofloods for brief periods—as long as they do not exceed the circuit's capacity. On daylight film both room lights and tungsten lamps cast yellow light, as in the picture above. The answer is to use tungsten-balanced film for these shots, or to fit a blue daylight-to-artificial light filter, which corrects the colour cast back to normal. This helps even with colour negative films.

USING A FILTER

The picture above was taken on daylight film with an 80A correction filter to remove the yellow cast—but it caused the daylight scene outside to look too blue. One answer is to frame so that you can see only the sky through the window. Another is to shoot when the light is very bright outside so that the window 'burns out' altogether. A third alternative is that idea used by the movie makers—cover the whole window with sheets of yellow filter! Yet another approach is simply to draw the curtains. Remember, no filter can correct for mixed lighting.

FILTERS TO USE INDOORS

Daylight film

Window light	No filter
Flash light	No filter
Photofloods	Blue D-to-A filter
Household lamps	82C filter

Tungsten balanced film

Window light	Orange A-to-D filter
Flash light	Orange A-to-D filter
Photofloods	1B Haze filter
Household lamps	20CC blue filter

Flashlight can be matched to tungsten light by fitting an orange-brown A-to-D filter over the flash gun.

Colour negatives are often automatically corrected for colour casts by the processors. With these a filter is not essential, but they will give better results than if no filter is used.

Colour slides always require a filter unless the film is matched to the light source.

Among the most fascinating photographs are those which capture movement and action. There is no such thing as 'instantaneous' exposure: there is always some time lag. But modern SLRs with shutter speeds of 1/500, 1/1000 or even 1/2000 can freeze action very effectively. Indoors, flash guns with bursts of flash as brief as 1/5000 do the same thing.

For most people, the enjoyment they get from action photography is linked to their enthusiasm for the action itself—the sport or the activity they are photographing. Field games, competitive athletics, cycling, steeplechasing, show-jumping, motor-racing and other events provide superb action subjects.

Each has its moments of maximum effort—like the moment when a sprinter passes his closest rival as they approach the tape, or when a rugby player dives for a touch down. These are the moments to look for. To catch them on film requires concentration and co-ordination above all things.

Following the action and catching the moment are far more important in this case than visualizing pictures and composing them with care. With these pictures it pays to use plenty of film while you have the opportunity, and select the best photographs later after processing.

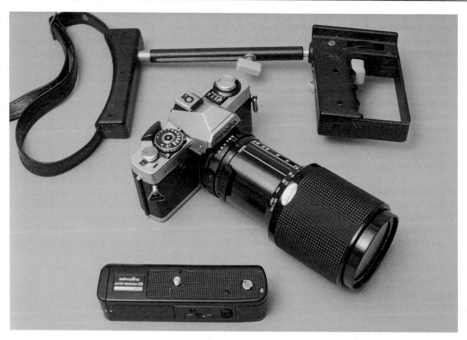

EQUIPMENT

For most action photography, your chief requirement is an SLR which gives you fast shutter speeds. A tripod is useful occasionally, but a pistol-grip is more manoeuverable. An auto-winder or motor drive is also a help.

ZOOM LENSES

Frequently at sporting events the photographer is unable to move around as much as he would like to. Added to this, his *subject* is constantly on the move. This makes a telephoto zoom extremely useful.

ANTICIPATING ACTION

Successful action shots need good reflexes and accurate anticipation. If you release the shutter when you see the action reach its peak, you will get shots like the one above, which was taken too late. Between your decision to release the shutter and the moment when the shutter actually fires there is a delay of about 1/15 sec—partly due to the workings of brain and hand, and partly due to the mechanical workings of the camera. It is important to learn exactly how long it takes you and your camera to react, and to time your action shots accordingly. You can only do this by practice: until then do not try to frame too closely on a subject which is moving across the frame.

ANGLE AND SHUTTER SPEED

Movement running across the field of view requires a faster shutter speed than movement towards or away from the camera (see Improver Course 6). This means that in poor light, for example, you can still get sharp pictures of a moving subject at shutter speeds around 1/125. Even when the movement is not *directly* towards the camera, as in the shot above, you can rely on a slower shutter speed. This picture was taken at 1/250: it would have needed at least 1/500 if the car had been travelling at right angles to the focal plane. This point of view loses none of the excitement of action: in many sports it allows you to catch the expressions of the sportsmen.

CATCHING THE PEAK

Every athletic action, like jumping, swimming or riding, has brief moments of hiatus—when there is least movement. A pole vaulter at the peak of his leap is a good example: at moments like this it is easier to freeze action even if the light is too poor to allow a very fast shutter speed. Typical 'peak points' include moments of impact in ball games, and the moment when a jumping horse—or athlete—is about to leave the ground. The top of any arc is also a hiatus point: the moment when a ball or athlete stops travelling upwards and begins to fall back to earth or, as in the picture above, the moment when a swing stops for an instant before it changes direction.

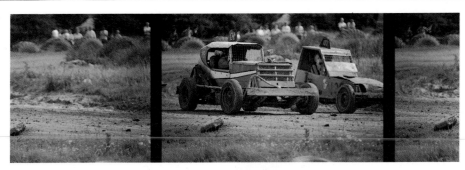

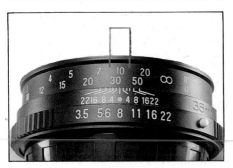

FOLLOWING FOCUS

It is fairly simple to keep a moving subject centred in the viewfinder of most SLRs: it is far more difficult to keep that subject in sharp focus. Swinging the camera round with the subject and smoothly changing focus at the same time—as it gets nearer or further away—takes a lot of skill. With a 'one-touch' zoom lens, you have to zoom and focus at the same time, which is even harder. The technique needs a lot of practice, so try following cars passing on a road to begin with, until you are very familiar with the action of your lens. When you buy a new lens, it is a great help if the focusing ring rotates in the same direction as the lenses that you have already.

PRESETTING FOCUS

An easier and more reliable method of focusing on a moving subject—a method used by many professional photographers—is to preset the focus of your lens on a spot which the subject is to pass close to. In the shots above, the lens was focused on a stone in the road. It is still important to follow the subject in the viewfinder, but there is no need to touch the focusing ring. (It is just as easy to follow an out-of-focus image in the viewfinder.) When the subject reaches the spot where you have focused, it then comes into sharp focus and you release the shutter. If you are using a zoom lens you can preset the focal length as well, to make sure that the subject fills the frame when it reaches the chosen position.

DEPTH OF FIELD

The area in sharp focus will depend on the chosen lens aperture (see section 31, page 66–7). Work this out from the depth of field scale on the lens, or by using the preview button. Remember that the depth of field is 1/3 in front of the focus point and 2/3 beyond.

MOTOR-DRIVES AND AUTO-WINDERS

An auto-winder or a motor-drive can be an advantage, especially if you are using more than one camera. You can leave a camera with an auto-winder on a tripod with the focus preset on a convenient point, and fire the shutter with a cable release when the action occurs, without even looking through the viewfinder. Most inexpensive auto-winders take between 1½ and 2½ frames per second if you keep the shutter release down. Do not imagine, however, that this is enough to catch all the best moments: usually it is better to time each shot individually. Motor-drives are more expensive but can often shoot at 3½ to 6 frames per second. This uses a lot of film, but allows you to shoot genuine action sequences, like the one above, with less chance of missing the best moment. With sequences like this you can show the action as it progresses as well as choosing the best shot of the series to stand alone.

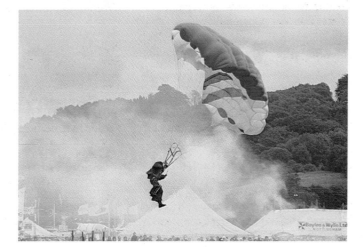

Accidental double exposures can be a disaster—a waste of two good pictures. Most SLRs have a safety lock that prevents this from happening: the shutter will not fire unless the film is first wound on. But on most cameras you can get round this to make *intentional* double exposures. By imagining what will happen when you expose two different views on the same piece of film, you can use this to get interesting new effects. The simplest form of multiple exposure is to combine two complete, separate images. Normally you can identify the whole of each image, but where dark or light areas overlap there appear extra shapes, tones and colours. Parts of each picture can disappear where the combined exposure produces pure white. But with more careful framing, you can put a small, brightly lit subject into the dark shadow area of a separate picture without affecting the rest. The skill here is in being able to imagine how the images will fit together without actually seeing the effect until the film is developed. Masks (which cover first one part of the lens and then the other) join images accurately. Very dark backgrounds make multiple pictures easy to take for your first trials. Later on you can try out more complicated techniques.

SPECIAL CONTROLS
Many SLRs have multi-exposure switches which are simple to use. After taking the first shot, simply move the switch to the 'multi' position. The lever wind then cocks the shutter without moving the film. Most types then return to normal automatically.

MANUAL METHODS
Tighten the film by rewinding until it resists. Hold the rewind crank firmly, press the rewind film release button and wind the lever: this cocks the shutter without moving the film. Wind on twice before the next shot as the film may not 'take up' straight away.

SPECIAL EFFECT MASKS
You can buy special masks or 'mattes' as part of a filter system or to fit certain lens hoods. Masks are used in pairs which correspond to one another: what one masks the other leaves open. Two shots are taken—one through each mask—on the same piece of film and the two images combine. In the picture above you can see the two masks used to give a centre-spot double exposure. Other masks allow you to expose the two halves of a single picture separately. Some are complex shapes, such as keyholes. It is not hard to make your own.
Exposure: measure exposures without the masks in place. As each shot exposes only *part* of the frame, you must give full exposure for each.

CENTRE-SPOT ONLY
This picture shows the effect (at the taking aperture) with the 'surround' bit of the double-exposure mask fitted. As the mask is very close to the lens it gives a blurry edge. At smaller apertures the edge becomes sharper.

THE FINAL EFFECT
The second mask has been used to blank out the centre spot while the surround has been exposed to produce this final picture. As blurry edges from both masks overlap, this avoids getting a definite join between the two images.

HOW TO COMBINE IMAGES
Light parts of one picture will always dominate the dark parts of another. If the sky in one shot is superimposed on a dark building in another, the building will either disappear or will be overlaid with details of the sky. *Highlights* will show up in a combination, whereas *shadows* will not—unless two dark areas coincide. The scene in the picture above called for an exposure of 1/125 at f11 (on 100 ASA film). To superimpose it on to a hoarding, right, the photographer first under-exposed the sign (at 1/250 at f16) and then reshot the village at full exposure using his fingers as a 'keyhole' mask. The central focusing ring is a help in lining up combined exposures in this way.

HIGHLIGHTS
Take a careful note of the highlights in a multiple exposure because these will stay bright in the final result. These parts of the film have been fully exposed so no further changes in the image are possible—only deterioration through over-exposure.

SHADOWS
Shadow areas in a multiple exposure are the places where a new image will show up most clearly because the film receives little exposure in dark areas and is ready to respond to more.
To begin with, experiment with combining these more obvious areas.

MULTIPLE EXPOSURE FACTORS
When you take more than one shot on the same piece of film, each one needs *less* exposure. (The combined effect of several normally exposed shots would over-expose the film.) This applies to multiple exposures where each exposure fills the frame.

Exposure guide
2 shots	minus 1 stop each
3 shots	minus 1 stop for first
	minus 2 stops for second
4 shots	minus 2 stops each
6 shots	minus 2 stops for four
	minus 3 stops for two
8 shots	minus 3 stops each
16 shots	minus 4 stops each

Where the exposures are uneven—one very bright and one dark, for example—you can vary these exposure adjustments, stopping down more for the brighter subject. But keep the overall number of stops subtracted within these limits.

Where a bright subject is superimposed on an area of total shadow, or when using masks that block parts of the film for exposure to light, give the normal full-frame exposure for each part.

MOVING SUBJECTS
If you have a tripod, you can use multiple-exposures to record movement. With the camera still, the background scene will stay sharp while a moving subject will appear in different parts of the frame for each exposure. Time the exposures evenly so that the images are evenly spaced, and choose intervals so that there is a slight overlap. (Totally separate images look ghost-like and do not convey motion well.) Auto-winders can be used to make multiple exposures with cameras which allow you to keep the multiple exposure switch turned on.

CAMERA MOVEMENT
When the subject is still you can move the camera between exposures on one frame to make patterns and create the effect of movement. Give slightly less—or more—exposure to each successive shot and you will create the impression that the subject is gradually fading or accelerating. The shot above could have been produced by either camera or subject movement. In fact the camera was still: the exposures were taken one minute apart to use the moon's movement. With no background detail the camera could ·equally well have been moved instead.

Most photographic dealers now offer a print-to-print copying service, so that you can obtain a copy of an 'instant' picture or if you don't have the negative. But it is still useful to be able to make your own copies—of prints, maps, plans, drawings or anything else that you are legally allowed to copy.

Remember that you should not make for commercial purposes a copy of any original which is copyright, taken by a professional photographer or printed in a book or magazine. Copyright normally expires 50 years after a picture was taken or, from 1957, after publication. As a basic guide UK copyright law permits copying for private study or research, but not for selling.

Copying can also provide a useful negative for further prints, or correct faults in the original. In colour, poor compositions—with tilted horizons, for example—can be remedied so that machine prints of the new negative come out far better. In black and white, brown/yellow stains or fading can be corrected: a blue filter will improve faded prints and an orange one makes stains disappear. Colour prints can be made into slides. And with the help of coloured card and instant dry lettering you can make your own titles for albums and so on.

STANDS AND LEGS

Copy stands hold the camera parallel to the print being copied. The one above is inexpensive and fits any round enlarger column and baseboard. Better versions have geared mounts. Some camera makes can supply copy legs, which fit on in place of a lens hood.

LIGHTING

To light any subject for copying you need two identically matched lights or flashguns. The stand shown here uses two photoflood lamps. It is easier to get good lighting if the lights are away from the stand and fully adjustable in position and height.

Slide copying has more potential than print copying if you are interested in creative effects. It is also easier to improve a badly exposed slide than a badly exposed print by copying it. Slides contain far more information than prints—with detail in the shadow areas that we cannot see—and a badly under-exposed slide can often be rescued by giving it extra exposure through a copier. The equipment you need is less elaborate and less expensive than for print copying. You will need no special lighting, though a flashgun will be useful. You can even use daylight, though this is variable and gives rather unpredictable results. There are copiers which fit bellows systems, ones which fit directly onto a standard lens and others which have their own lenses and fit onto an SLR body. Most of these copiers make slides which are nominally the same size as the original, but in fact they magnify slightly. This is because slide mounts crop 1/500in (0.5mm) off the edges of a slide, and this intruding mount edge must not be allowed to appear as a frame around the edge of the copy. Zoom or bellows copiers provide greater flexibility, enabling the main subject to be more tightly cropped or sections enlarged.

BELLOWS COPIERS

Simple bellows attachments like the one above (on the right) cost little, but they let in light between the slide and the copy lens. Use them in subdued light and with flash. Better models have a bellows linkage between the lens and the slide holder.

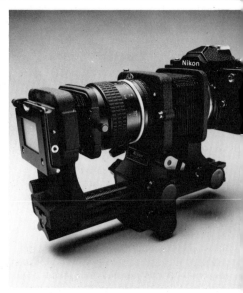

SEPARATE COPIERS

Separate copiers need no bellows, but they cost more. Fixed focus types make 'same size' (1:1) copies, but others like the one above zoom from 1;1 to 1;2, so that 1/4 of the original slide fills the frame, giving a selective crop. Use either flash or daylight.

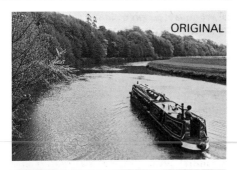
ORIGINAL

COPY

SETTING UP
To get the camera parallel to a flat subject without a copy stand, place a pocket mirror on top of the subject. Looking through the viewfinder, adjust the camera so that the reflection of the lens is exactly central in the viewfinder. Use the central focusing aid to help you. Then, to light the subject, have the two lights equally spaced on either side of the narrower edges of the subject. If there are reflections or diffused glare, position the lights lower. Use the pencil test (shown above) to check the shadows to make sure that the lights are symmetrical. If the two shadows cast by the pen or pencil seem to be the same density at equal distances from the centre, then the lighting must be fairly even.

MAKING A TEST
To test your copying set-up, use a flat subject with good colours and a matt finish—something that you will be able to compare with the finished copy. You can buy a commercially made colour checker, or make one yourself (like the one above) to find out what adjustments you need to make for your regular film. Do not expect perfect reproduction of all colours the first time. Correct colour casts by using colour printing filters or colour compensating filters. Make notes of all your test shots, altering the exposure by half a stop at a time. Once you have found the best copying exposure and filters, record the distances of your copy lights so you can repeat successful results.

ELIMINATING STAINS
Old black and white prints may have brown stains. They can be removed, as shown above, by copying the print through an orange or red filter on to fine grain film. A blue filter restores contrast to faded, yellowish prints, but will show up stains badly.

COLOUR AND CONTRAST
For the most exact copies of slides, it is best to use special copy film. This is available only in bulk lengths, however, and unless you are making a large number of copies it is not worth loading it into cassettes. Kodachrome 25 is a good alternative. Copying slides on to normal slide film increases contrast, loses some of the sharpness in fine detail and may slightly change the colour. You can adjust the colour (or correct a colour cast in the original slide) by using filters. You can also adjust the final effect by changing exposure over a wide range. The two slides above are both copies of the same slide and show a one-stop change in exposure during the copying. Both are acceptable.

LIGHTING AND EXPOSURE
Daylight slide film gives the best results with electronic flash. Position your flash about 20in (40cm) from the opal diffuser behind the slide in the copier and make a series of test exposures: with bellows copiers try different f stops and with separate copiers try different distances. Record the details of each and compare the results with the originals. You can also use a photoflood bulb and tungsten balanced film such as Ektachrome 50. Meter the amount of light with your TTL meter in the normal way to find out the correct exposure, but always bracket exposures for important copies. In an emergency use natural light, aiming the copier at a white card for accurate colour reproduction.

BENCH COPIERS
These use either flash or tungsten light. Less expensive ones take the place of a print on a normal copying stand. This one has its own bellows and copying stand, but costs more.

'The camera never lies' may not be entirely true, but normal photographs are usually an accurate representation of the scene as it really was. There is no reason, however, why you should not change a photograph afterwards. There are many ways of using parts of photographs to create new pictures, or of simply changing a print by colouring it. Two or more photographs can be combined; details can be removed; new elements can be added. All these changes mean a loss of the 'pure' photographic representation, though with care the results can be copied or reprinted so that they look quite natural.

Combined images are made in two basic ways: by superimposition and by montage. Superimposition is a photographic technique and requires two pictures which — when double exposed onto one frame — form a new image. Montage involves cutting and assembling parts of pictures in a sort of jigsaw image.

Coloured images can involve changing all or part of the image, or even concealing parts of it. You can also add tints to a black and white print. If making monochrome prints specially for tinting, make them light in tone and with a softer contrast than usual.

CUTTING AND MONTAGE
For print montage you will need a pair of very sharp scissors (like the ones in the picture) or a craft knife and cutting mat. Spray Mount adhesive is easy to use, and allows you to peel off and reposition the elements freely.

COLOURING PRINTS
Special photographic tints are made in both gouache (opaque) and watercolour (transparent) forms. Photo oil colours are semi-transparent. Felt-tip markers and overhead projector colouring pens are also useful.

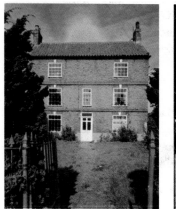
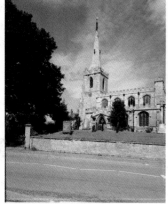

CUT AND PASTE MONTAGE
You do not need your own darkroom for cut and paste montage. Simply look out your spare prints and select suitable ones which promise to make an interesting combination. Then make traces of them with tracing paper to check whether your ideas will work and fit together. Cut the picture elements out using very sharp scissors or a craft knife and paste the backs lightly with Cow Gum or Spray Mount: both of these products allow you to stick down and then remove the prints before finally rubbing them into place. Mount the elements of your picture onto board, slightly overlapping them. This was done in the picture on the right, and the join is hard to see. For even better results, slice through both pictures at once with a craft knife before sticking them so that they make a perfect join when stuck down, or cut the top print at an angle so the edge is thin.

Shots taken on the same film, with the same lens and with the sun at the same angle, are quite convincing when combined.

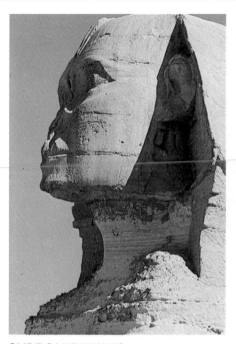

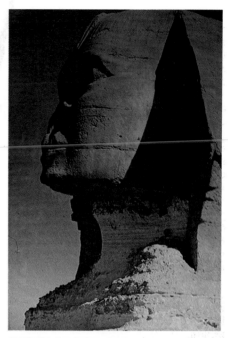

SLIDE SANDWICHES

The two pictures above have been chosen to work as a superimposed picture. If you want to use a slide with mainly light detail and superimpose a darker element, you need not do it in the camera. Simply buy a glass slide mount and bind both frames of film together as a sandwich. Typical examples of this could include putting an aeroplane into an empty sky, or a sunset behind a silhouetted skyline with a plain sky. A slightly sharper result is obtained with the emulsion sides together.

CHOICE OF PICTURES

Avoid complicated slides or prints when making copy superimpositions. At least one of them should be very simple, like the middle picture in this case. This means that you need only concentrate on positioning one part of the slide.

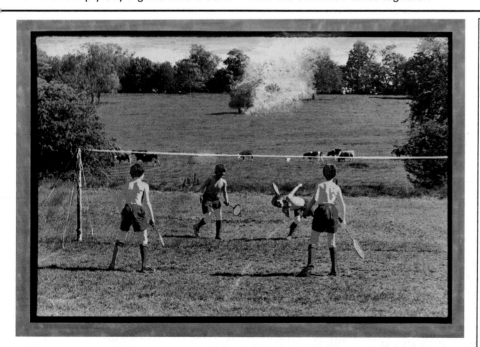

PHOTO COLOURING

The print above shows a variety of colouring methods. The green on the left is photo dye. The sky is white gouache mixed with blue dye, and the boys are painted over with several opaque gouaches.

RETOUCHING AND DYEING

The orange border and strong green tree on the right are done with felt-tip 'magic markers'. A white cow above the central boy's head was removed with grey gouache. The 'burning bush' was made with opaque white and clear tint.

PHOTO COLOURING IDEAS

Effect needed	What to use
Strong colour	Undiluted photo tints; felt-tip pens; food dyes; indian ink
Concealing detail	Photo gouache; acrylic paint; oils; Snopake and dyes
Improve colour	Photo retouching dyes
Remove blemishes	White gouache overpainted with tints
Black and white	Soft pencil (2B)
Overall colour	Immerse in dilute photo tint or food dye; cover with plasic film
coloured border; picking out detail	Felt-tip pens permanent OHP pens

Make your first experiments with old prints, until you have mastered your colouring materials. Do not expect a completely natural result straight away. Use the colour for creative or graphic effects instead.

Unlike prints, which are easily replaced from the original negative, slides are irreplaceable if damaged. Treat them with great care. To begin with, poor processing will spoil a slide for ever, so if you use film which can be processed by any processors, use the best company you can find or afford. Many of the top professional processing laboratories do not mount slides for projection unless you pay extra, but return them like negatives in uncut strips. Mounted slides can be stored in three different ways.

In boxes: you can leave slides in the boxes they are returned in, removing them every time you want to project them. Always label the tops of the boxes.

In magazines: transfer the slides in order into magazines ready for projection, or into boxes with slots from which they are transferred into the magazines.

In plastic sheets: file your slides in clear plastic sheets in a ring binder or suspension file. This way you can hold up a sheet of twenty or more to the light (or lay the sheet on a light box) and see all the slides at the same time—particularly useful if you are searching for one slide. Always store your slides in a cool, dry place, to prevent fading.

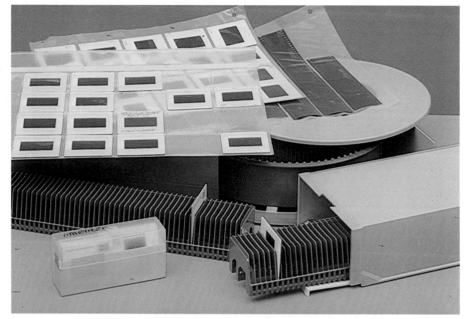

BOXES
The film-makers' own boxes take up the least space (lower left of picture). Transfer trays, like the circular one shown here (top right) take up most space. Projector magazines (lower right) are a good compromise, and the slides are ready to show instantly.

FILING SHEETS
Plastic filing sheets (top left) vary in size and cost. Choose ones that fit either ring binders or suspension files and stick to these. You can also buy special carrying cases for suspension sheets. Plastic sheets help to protect your slides.

Negatives are normally kept in their original strips. Some firms refuse to print from single negatives cut from the strip, and with some enlargers it may be harder to print them at home. For convenience, 20-exposure films are usually cut into strips of five and 24-exposure and 36-exposure films into strips of six. (If you get 37 pictures on a roll, try to drop a bad or wrongly exposed shot.) To make it easier to find a negative when you want a reprint, give each film its own number and keep a complete record of where the negatives are by subject and by date. Never split up complete films. There are two main methods of filing your negatives.

In bags: each part of the film is kept in its individual bag and the strips are kept together in a card folder.

In a filing sheet: you can buy negative filing sheets in various sizes which fit into a ring binder.

With the first method it is easier to lose one strip, but the ring binder sheets need more careful handling and cost more. Whichever method you choose, make sure that the negative holders are carefully labelled and that the negatives are kept safely in a clean dry place, well away from any direct heat.

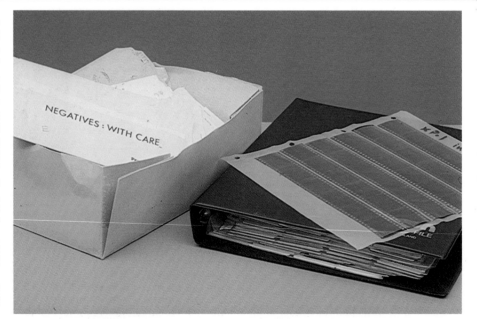

THE WRONG APPROACH
The 'shoebox' system, shown on the left, is no help in finding your negatives. Nor does it take care of them in any way. If you keep your negatives in the individual strip bags, organise a proper filing drawer or a box for them.

A COMPLETE SYSTEM
The ring binder, on the right, is larger than a normal office binder. It holds all your pictures—negatives in sheets (top) and slides, either mounted or unmounted. This is useful if you tend to take both slides and negatives at the same time.

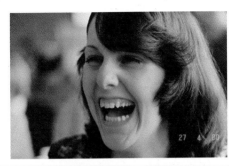

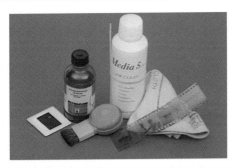

DATA BACK REFERENCING

The more slides you collect, the more difficult it is to remember when they were taken. Kodak cardboard mounts are a help as they have a date which tells you when the slide was processed—but not when it was taken. A data back, available for many makes of camera, prints a small day-month-year code (or other form of annotation) at the very edge of each shot, as shown above. On a normal enprint, the figures are about 1/5in (3mm) high. These figures are permanent and can never be erased when the slide is remounted. Some databacks print the figures rather too prominently, however, and spoil the picture. It is often better simply to keep a record of the shots you take and write the date on each picture later.

CLEANING SLIDES

Too much handling makes your slides dirty. You can protect slides by mounting them in glass or plastic mounts, but always clean them first. Blow the dust off with a blower brush (lower centre) or aerosol jet (top centre). Wipe any fingermarks, like the one on the right, with a soft cotton pile cloth—which must be washed frequently. Use film-cleaner solutions for really stubborn greasy marks, but always remove the slide from its mount—particularly if it is a hollow plastic mount—before you do so. You can mask scratches with a lacquer like Repolisan (top left). These cleaning methods can also be used for negatives, but go gently. Usually a blower brush should be enough.

CONTACT SHEETS

Contact sheets can be made from all kinds of negatives and also from unmounted slides. They cost about the same as a package of enprints from a film. (In the picture above the contact sheet is from a medium format roll-film camera.) If you attach a sticky edge-strip to the sheet and punch holes in it, you can keep the contact sheet next to the negatives in a ring binder. In your darkroom, you can make contact sheets from negatives kept in plastic filing sheets—like the top one in the picture—without removing the negatives. Paper negative filing sheets are cheaper, but do not allow you to do this. You have to remove the negatives and make your contact sheet using glass or a contact printing frame.

PRINT AND NEGATIVE FILES

Because contact sheets are expensive— unless you can make them yourself— you may prefer to use a system which keeps the processed prints and negatives together. The picture above shows a print and negative file. Each file will hold eight sets of prints separately, and in the drawer underneath you can keep folders with individual negative strips inside. As long as you still have the print you will be able to find the negative. Write reference numbers on each print, and the same on the negative filing wallets. The largest print size the file will take is 5 x 4. You can also buy albums which have a pocket at the back to hold the negatives, but these hold fewer pictures.

CHOOSING A STORAGE SYSTEM

You want to file	You need
Negatives only	Ring file
Negatives/enprints	Print box
Negatives/contacts	Ring file
Mixed slides	Ring file
Slides in sets	Own boxes
For automatic projector	Magazines Transfer trays
For manual projector	Slotted boxes
Uncut slides	Ring binder
Slides/negs/contacts	Ring binder
Indexed slides	Suspension file
Negatives/large prints	Albums with negative pocket

Glossary

Words in *italics* appear as separate entries.

A

Angle of view This is the maximum angle 'seen' by a lens. Most so-called standard lenses (for example 50mm on a 35mm camera) have an angle of view of about 50°. Lenses of long focal length (200mm for example) have narrower angles and lenses of short focal length (eg 28mm) have wider angles of view.

Aperture The circular opening within a camera lens system that controls the brightness of the image striking the film. Most apertures are variable—the size of the film opening being indicated by the f number.

Aperture priority A term usually applied to an in-camera automatic exposure system where the aperture is first selected by the photographer and the camera automatically sets the appropriate shutter speed (for the scene, brightness and film being used). Most aperture priority systems are connected to an electronic shutter and the camera-selected speed is usually indicated in the viewfinder.

ASA American Standards Association. The sensitivity (speed with which it reacts to light) of a film can be measured by the ASA standard or by other standards systems, such as DIN. The ASA film speed scale is arithmetical—a film of 200 ASA is twice as fast as a 100 ASA film and half the speed of a 400 ASA film.

Astigmatism An aberration of lenses and of the human eye. It is the inability of the lens system to focus, simultaneously, lines in the same plane but at right angles to each other. Only one of these two lines appears correctly focused at any one time.

Automatic exposure
A system within a camera which automatically sets the correct exposure There are three main types:
1 Aperture priority—the photographer selects the aperture and the camera selects the correct shutter speed.
2 Shutter priority—the photographer selects the shutter speed and the camera sets the correct aperture.
3 Programmed—the camera sets an appropriate shutter speed/aperture combination according to a pre-programmed selection.

Automatic focusing Cameras with built-in automatic focusing correctly set the focus of the lens for the subject which needs to be fairly central. These cameras use either an opto-electronic system (comparison of two separate light paths from the subject) or an ultra-sonic system which has a special ultrasonic/transmitter receiver. At present these systems are only available in relatively simple cameras.

Auto-winder In the strictest sense an auto-winder is a unit which can be attached to many SLRs for motorized, single frame film advance. After each exposure the auto-winder automatically advances the film to the next frame and cocks the shutter. Many units, however, are capable of modest speed picture sequences. Some cameras have an auto-winder built into the main body.

Available light A general term describing the existing light on the subject. It normally refers to levels of low illumination—for example, at night or indoors. These conditions usually require fast films, lenses of large aperture—for example, f2—and relatively long exposure times.

B

Bayonet mount A type of fitting on lenses, extension tubes, and other attachments which enables them to be quickly and easily mounted to the camera body. The usual procedure is to line-up a mark on the attachment with one on the camera, join the two, and turn the attachment (usually counterclockwise) through about 60°. Removal of the attachment is just as simple. There are several types of bayonet mount in use, only some of which are interchangeable through the use of adapters.

B camera setting A shutter set to B remains open as long as the shutter release is depressed. To avoid camera shake it is advisable to use a cable release when making long exposures using the B setting.

Bellows A concertina-like unit that fits between the camera body and the lens. A bellows unit enables the lens to focus on close subjects, and gives a large image of the subject. The magnification of the subject depends on the focal length of the lens and the extension of the bellows. For example, using a bellows unit with a 50mm lens on a 35mm camera gives a subject magnification range of about ×1 (that is, lifesize) to ×3.

Bounce light Light (electronic flash or tungsten) that is bounced off a reflecting surface. It gives softer (more diffuse) illumination than a direct light and produces a more even lighting of the subject. Use white surfaces which do not absorb light or impart colour.

Bracketing To make a series of different exposures so that one correct exposure results. This technique is useful for non-average subjects (snowscapes, sunsets, very light or very dark tones objects) and where film latitude is small (colour slides). The photographer first exposes the film using the most likely camera setting, found with a light meter or by guessing. He then uses different camera settings to give more and then less exposure than the nominally correct setting.

C

Cable release A flexible cable which is attached (usually screwed-in) to the shutter release and used for relatively long exposure times (1/8 and more). The operator depresses the plunger on the cable to release the shutter, remotely. This prevents the camera from moving during the exposure.

CC filters These are 'colour correcting' or 'colour compensating' filters which may be used either in front of the camera or when printing colour film, to modify the final overall colour of the photograph. Their various strengths are indicated by numbers usually ranging from 05 to 50. Filters may be combined to give a complete range of colour correction.

Close-up attachment Any attachment which enables the camera to focus closer than its normal closest distance. Such attachments include close-up lenses, bellows and extension tubes.

Colour negative A type of film which is used primarily to give colour prints; although colour transparencies and black and white prints may also be produced. The colours of a colour negative are complementary in colour and hue to the original subject colours.

Colour reversal A colour film or paper which produces a positive image directly from a positive original. Thus a colour reversal film gives a colour transparency directly from the original scene and a colour reversal paper, like Cibachrome or Ektachrome paper, gives a positive print directly from a transparency. Most colour reversal materials are identified by the suffix 'chrome'.

Colour temperature Different white light sources emit a different mixture of colours. Often, the colour quality of a light source is measured in terms of colour temperature. Sources rich in red light have a low colour temperature—for example, photofloods at 3400 (Kelvin)—and sources rich in blue light have a high colour temperature—for example, daylight at 5500K. Colour films have to be balanced to match the light source in use, and films are made to suit tungsten lamps (3200K) and daylight (5500K).

Complementary colours These are pairs of colours which, when mixed together, give a grey (neutral). For example, a grey is formed when yellow and blue light are mixed together; therefore, yellow is complementary to blue and vice versa. Other complementary colours include green and magenta, red and cyan.

D

Daylight colour film A colour film which is designed to be used in daylight without or with electronic flash or blue flash-bulbs. This film type can also be used in tungsten or fluorescent lighting if a suitable filter is put in front of the lens or light source.

Depth of field The distance between the nearest and furthest points of the subject which are acceptably sharp. Depth of field can be increased by using small apertures (large f numbers) and/or short focal-length lenses and/or by taking the photograph from further away. Use of large apertures (small f numbers), long focal-length lenses, and near subjects reduces depth of field.

Depth of field preview A facility available on many SLR cameras which stops down the lens to the shooting aperture so that the depth of field can be seen.

Differential focusing The technique of using wide apertures (small f-numbers) to reduce depth of field, and to therefore separate the focused subject from its foreground and background.

Diffused image An image which has indistinct edges and appears 'soft'. Overall- or partially-diffused images can be produced in the camera by using special lenses and filters, or by shooting through various 'filmy' substances such as vaseline, sellotape, and fine stockings. Images may also be diffused during enlarging by placing a diffusing device between the enlarging lens and the paper.

DIN Deutsche Industria Normen. A film speed system used by Germany and some other European countries. An increase/decrease of 3 DIN units indicates a doubling/halving of film speed, that is a film of 21 DIN (100 ASA) is half the speed of 24 DIN (200 ASA) film, and double the speed of an 18 DIN (50 ASA) film.

Double exposure The process of exposing two separate images on one piece of film or paper. This is a relatively simple procedure when enlarging and when using most medium and large format cameras, but can be quite difficult with most 35mm cameras. Visually successful double exposures are best achieved when the photographer carefully plans the result.

E

Electronic flash A unit which produces a very bright flash of light which lasts only for a short time (usually between 1/5000–1/4000 second). This electronic flash is caused by a high voltage discharge between two electrodes enclosed in a glass cylindrical bulb containing an inert gas such as argon or krypton. An electronic flash tube will last for many thousands of flashes and can be charged from the mains and/or batteries of various sizes.

Expiry date The date printed on film boxes which indicates, under average temperature and humidity conditions, when the film might produce unacceptable results. Films stored at low humidity can be used well past their expiry date.

Exposure The result of allowng light to act on a photosensitive material. The amount of exposure depends on both the intensity of the light and the time it is allowed to fall on the sensitive material.

Exposure meter An instrument which measures the intensity of light falling on (incident reading) or reflected by (reflected reading) the subject. Exposure meters can be separate or built into a camera; the latter type usually gives a readout in the viewfinder and may also automatically adjust the camera settings to give correct exposure.

Extension rings (tubes) Spacer rings which fit between the camera body and the lens, and allow the camera to focus on subjects closer than the nearest marked focusing distance of the lens. A set of rings typically allows a focusing range of 56–20cm for a standard 50mm lens. These extension rings may be non-automatic or automatic; the latter type allow full-aperture focusing just prior to exposure.

F

Fast films Films that are very sensitive to light and require only a small exposure. They are ideal for photography in dimly lit places, or where fast shutter speeds (for example, 1/500) and/or small apertures (for example, f16) are desired. These fast films (400 ASA or

more) are more grainy than slower films.

Fill light Any light which adds to the main (key) illumination without altering the overall character of the lighting. Usually fill lights are positioned near the camera, thereby avoiding extra shadows, and are used to increase detail in the shadows. They are ideal for back-lit portraits, studio work, and where lighting is very contrasty (such as bright cloudless days).

Filter Any material which, when placed in front of a light source or lens, absorbs some of the light coming through it. Filters are usually made of glass, plastic, or gelatin-coated plastic and in photography are mainly used to modify the light reaching the film, or in colour printing to change the colour of the light reaching the paper.

Flare A term used to describe stray light that is not from the subject and which reaches the film. Flare has the overall effect of lowering image contrast and is most noticeable in the subject shadow areas, it is eliminated or reduced by using coated lenses (most modern lenses are multi-coated), lens hoods, and by preventing lights from shining directly into the lens.

f numbers The series of internationally agreed numbers which are marked on lenses and indicate the brightness of the image on the film plane—so all lenses are focused on infinity. The f number series is 1·4, 2, 2·8, 4, 5·6, 8, 11, 16, 22, 32 etc—changing to the next largest number (for example, f11 to f16) decreases the image brightness to ½, and moving to the next smallest number doubles the image brightness.

Focal length The distance between the optical centre of the lens (not necessarily within the lens itself) and the film when the lens is focused on infinity. Focal length is related to the angle of view of the lens—wide-angle lenses have short focal lengths (for example 28mm) and narrow-angle lenses have long focal lengths (for example, 200mm).

I

Interchangeable lens A lens which can be detached from the camera body and replaced by another lens. Each camera manufacturer has its own mounting system (screw thread or bayonet type) which means that lenses need to be compatible with the camera body. However, adaptors are available to convert one type of mount to another.

L

Latitude When used in connection with films, latitude refers to the amount of under- and over-exposure permissible to achieve acceptable images.

LEDs Light emitting diodes. These are electronic devices for displaying information. They are used for a number of photographic purposes, including the indication of under- or over-exposure, or the selected aperture/shutter speed combination.

Lens hood (shade) A conical piece of metal, plastic or rubber which is clamped or screwed on to the front of a lens. Its purpose is to prevent bright light sources, such as the sun, which are outside the lens field of view from striking the lens directly and degrading the image by reducing contrast (flare).

M

Macro lens A lens which focuses on very near subjects without the aid of close-up devices such as extension tubes or close-up lenses. Most macro lenses can produce an image which is ½ life size on the film. See also *Photomacrography.*

Microprism A small glass prism which is often used in large numbers in the centre of camera focusing screens to aid focusing. When the image is out of focus the prisms refract the light and cause the image to 'shimmer'; the image becomes clear when correctly focused.

Mirror lens Any lens which incorporates mirrors instead of conventional glass (or plastic) lens elements. This type of lens design is employed mainly for long focal length lenses (eg 500mm), and produces a relatively lightweight lens with a fixed aperture (about f8).

Motor-drive A motor-drive provides motorized film advance, both single frame and sequence. Motor-drive units are generally capable of much faster sequence rates (given in frames per second -fps) than auto-winders and can be used with a wider range of accessories.

N

Negative A general term which is often used to describe a negative image on film, whether it be in black and white or colour. See also *Negative image.*

Negative image Any image in which the original subject tones (and/or colours) are reversed.

Normal lens a phrase sometimes used to describe a 'standard' lens—the lens most often used, and considered by most photographers and camera manufacturers as the one which gives an image most closely resembling normal eye vision. The normal lens for 35mm cameras has a focal length of around 50mm.

O

Over-exposure Exposure which is much more than the 'normal' 'correct' exposure for the film or paper being used. Over-exposure can cause loss of highlight detail and reduction of image quality.

P

Panning The act of swinging the camera to follow a moving object to keep the subject's position in the viewfinder approximately the same. The shutter is released during the panning movement.

Pentaprism An optical device, used on most 35mm SLR cameras, to present the focusing screen image right away round and upright.

Photoflood An over-run (subjected to a higher voltage than the bulb is designed for) which gives a bright light having a colour temperature of 3400K.

Photomacrography Close-up photography in the range of ×1 to about ×20 life-size on the film.

Polarized light Light which vibrates in only one plane as opposed to non-polarized light which vibrates in many planes.

Polarizing filter A polarizing (or pola) filter, depending on its orientation, absorbs polarized light. It can be used to reduce reflections from surfaces such as water, roads, glass, and also to darken the sky in colour photographs.

R

Reciprocity law failure Failure of the reciprocity law (which states: exposure = image brightness at the focal plane × shutter speed) manifests itself in loss of sensitivity of the film emulsion and occurs when exposure times are either long or very short. The point of departure from the law depends on the particular film, but for most camera films it occurs outside the range 1/2–1/1000 second, when extra exposure is needed to avoid under-exposure.

Red eye The phenomena of red eyes can occur when taking colour portraits by flashlight. They are avoided by moving the flashgun further away from the camera.

Reflected light reading A light meter reading taken by pointing the meter at the subject. It measures the light being reflected from the subject and the actual reading is obviously influenced by the nature of the subject.

Reflector Any surface which is used to reflect light towards the subject, and especially into shadow areas. They may be curved metal bowls surrounding the light source or simply a matt white board.

Retrofocus A type of lens design which permits short focal-length lenses to be mounted further away from the focal plane than conventional lenses of the same focal length. This design allows wide-angle lenses to be used with reflex viewing systems.

Ring flash A circular-shaped electronic flash unit which is positioned around the camera lens and produces shadowless lighting of the subject. It is ideal for much medical and scientific close-up work.

S

Selective focus The technique of choosing a particular part of a scene to focus on. The aperture setting determines whether this selected portion of the scene alone is in focus or whether it is simply the centre of a zone or sharp focus. See also *Differential focusing.*

Shutter priority An automatic-exposure system whereby the photographer first selects the shutter speed and the camera then automatically sets the correct aperture.

Single lens reflex (SLR) A camera which views the subject through the 'taking' lens via a mirror. Many SLRs also incorporate a *pentaprism.*

Slide copier Device which produces a duplicate slide. Slide copiers range from simple 'lens attachments' to sophisticated professional units.

Stopping down The act of reducing the lens aperture size ie. increasing the f-number. Stopping down increases the depth of field and is often used in landscape and advertising work, where sharp detail is needed over all the subject.

T

Teleconverter An optical device which is placed between the camera body and lens, and increases the magnification of the image. For example, a ×2 converter when combined with a 50mm lens, gives effectively a 100mm lens. These combinations are inferior to equivalent focal length lenses, but are much cheaper and easier to carry.

Telephoto lens A long focal-length lens of special design to minimize its physical length. Most narrow-angle lenses are of telephoto design.

Through-the-lens (TTL) metering Any exposure metering system built into a camera which reads the light after it has passed through the lens. TTL metering takes into account filters, extension tubes and any other lens attachments. These meters give only reflected light readings.

Tungsten film Any film balanced for 3200K lighting. Most professional studio tungsten lighting is of 3200K colour quality.

Tungsten-halogen lamp A special design of tungsten lamp which burns very brightly and has a stable colour throughout its relatively long life. Its main disadvantages are the extreme heat generated and obtaining precise control of lighting quality.

U

Underexposure Insufficient exposure of film or paper which reduces the contrast and density of the image.

Uprating a film The technique of setting the film at a higher ASA setting so it acts as if it were a faster film but is consequently underexposed. This is usually followed by overdevelopment of the film to obtain satisfactory results.

V

Viewfinder A simple device, usually optical, which indicates the edges of the image being formed on the film.

W

Wide-angle lens A short focal-length lens which records a wide angle of view. It is used for landscape studies and when working in confined spaces.

Z

Zoom lens A lens having a range of focal lengths. One zoom lens can replace several fixed focal-length lenses, but results are likely to be inferior.

Index

Photographic credits
All photographs David Kilpatrick/Eaglemoss except the following:
Malcolm Aird/Eaglemoss 14 (bottom centre)
Robert Ashby 17 (bottom right)
Tim Beddow 15 (bottom right), 23 (bottom centre)
Steve Bicknell/Eaglemoss 9 (top centre), 15 (bottom left), 33 (top left)
Michael Busselle/Eaglemoss 6–7, 53 (top left and centre)
Ed Buziak 13 (top left)
Anne Conway 25 (top right), 56 (bottom centre)
Eric Crichton/Courtesy of Worldwide Butterfly Farm 38 (bottom right)
England Scene Picture Library 84 (bottom centre)
John Garrett 46 (top), 70 (top)
John Goldblatt 8 (bottom centre)
Alfred Gregory 12 (bottom left)
John Benton Harris 75 (top right)
James Harrison 49 (bottom left)
A. Houghton 93 (top left)

Shirley Kilpatrick 76 (bottom left)
Lawrence Lawry/Eaglemoss 51 (top right), 56 (bottom right)
Steve Lister 25 (bottom centre), 29 (bottom right)
T.A. Lovell 33 (top right)
Neill Meneer 46 (bottom)
Tom Nebbia/Aspect 12 (bottom right)
David Parker 91 (top)
Rémy Poinot 79 (bottom left)
Tina Rogers 8 (bottom right)
Jack Schofield 9 (top left and right), 47 (bottom left and right), 48 (bottom right), 75 (bottom left)
Japanese Cameras Ltd 74 (bottom right)
Richard Steedman/Image Bank 74 (bottom left)
Malcolm Warrington/Eaglemoss 10 (top centre)

Artwork credits
Jim Bamber 14 (bottom left and right), 15
Christian Baker Associates 12–13
Drury Lane Studios 16, 20–22

David Parker 18–19
Jenny Pentecost 32, 41, 51–3, 74–5, 78, 82
Rich Designs 8–11, 14 (top), 26–7, 30–1, 34–6, 38, 44, 46–9

Editorial credits
The Author David Kilpatrick is a photographer and journalist well known to the photographic enthusiast. He has been contributing editor of the magazines *Photo Technique* and *Camera,* and has contributed widely to *You and Your Camera.* He has been responsible as Editor for the relaunch of the professional magazine *The Photographer* and the initial launch of *Creative Photography* magazine. David Kilpatrick organizes the Minolta Club of Great Britain and edits the quarterly, *Minolta Image.*

Cover: Malcolm Warrington and Kim Sayer
Page 4: Tony Duffy/All-Sport